SOUTHERN EXPOSURE

LEE BEY

Foreword by Amanda Williams

SOUTHERN EXPOSURE

The Overlooked Architecture of Chicago's South Side

NORTHWESTERN UNIVERSITY PRESS

EVANSTON, ILLINOIS

Northwestern University Press
www.nupress.northwestern.edu

Graham
Foundation Northwestern University Press gratefully acknowledges the support of the the Graham
Foundation for Advanced Studies in the Fine Arts.

Printed in Canada

10 9 8 7 6 5 4 3 2 1

Library of Congress Cataloging-in-Publication Data
Names: Bey, Lee, 1965– author. | Williams, Amanda, writer of foreword.
Title: Southern exposure : the overlooked architecture of Chicago's South Side / Lee Bey ; foreword by
 Amanda Williams.
Description: Evanston, Illinois : Northwestern University Press, 2019. | The notion of this book began as a
 photography exhibit, Chicago: A Southern Exposure, created for the 2017 Chicago Architecture Biennial.
Identifiers: LCCN 2019015313 | ISBN 9780810140981 (trade paper : alk. paper)
Subjects: LCSH: Architecture—Illinois—Chicago—History. | Architecture—Illinois—Chicago—
 Pictorial works. | South Side (Chicago, Ill.)—Buildings, structures, etc.
Classification: LCC NA735.C4 B49 2019 | DDC 720.9773/11—dc23
LC record available at https://lccn.loc.gov/2019015313

To Lee and Lula. Your love and encouragement made everything possible.

CONTENTS

AMANDA WILLIAMS

"This Christmas" is my favorite song by Chicago native Donny Hathaway. I play it year-round despite its intended seasonal theme. Each time I hear it, a smile escapes my lips, my mood lightens, and sometimes joyful tears fill my eyes.

There is a magic to its opening arrangement. The horns burst in—*baah daah dah dah dahh ba bahhh ba dah dah daaaahh*; tambourines, triangles, bells, and other percussion instruments follow with a festive baseline; strings and a keyboard sneak in last. The instruments then quiet their exuberance just enough to allow Hathaway's melodic voice to emerge. I am confident when he croons to me "I'm gonna get to know you better . . ."

This is how I feel every time I see a Lee Bey photograph of the South Side. It goes without saying that his photographs are layered with the technical competence and complexity necessary to make them strong images—form, line, color, light, the push and pull of compositional balance are all apparent. He knows what he's doing.

But there is something else. It's the way he tells *his* love story for the South Side as a story about a people's history in a place. His images tell stories about not just any South Side, but *my* South Side, and all of us who came of age in a certain era—anyone who remembers Moo & Oink.

For me, this collection of images in *Southern Exposure: The Overlooked Architecture of Chicago's South Side* is like Christmas every day. Almost every photograph brings an associated memory of my connection to that place, be it a direct relationship or an anecdote about how it served as a backdrop and sometimes foreground of strong family reminiscences of the everyday—driving to a childhood friend's birthday party, my brother and I going on Saturday errands with my mom, or tagging along to meetings with my accountant father who provided services for many of the companies housed in the structures shown on these pages.

King Drive, Pride Cleaners, and the Overton Building are locations that we can visit at any time, but Lee has captured them in a way that folds in shared memories about an importance that goes beyond their programmatic function or architectural identity. These are places that have incubated black excellence in all its forms: multimillion-dollar companies, individual innovators, historic entertainers, and political figures. The stylistic ambition of these Chicago greats was often reflected in their architectural choices. Statements about beauty were baked into their aspirations. This part of the story is often overlooked or omitted altogether.

These architectural photographs not only chronicle the story of the economic success of the South Side's black elite but display side-by-side the spatial by-products of the immense amount of sacrifice, labor, and toil that came along with the unprecedented level of the black South Side's professional and personal gains. These images also bring to light the residential architecture that contained the interior lives of Lee's family, my family, and those of millions of black Chicagoans who called the South Side home from the Great Migration through today.

The descriptor "The first black . . ." precedes the addresses and names of the

occupants of many of the buildings on these pages. For example, the First Church of Deliverance, an early black megachurch, was designed by two black firsts: Walter T. Bailey, the state's first licensed black architect, and Charles S. Duke, one of the first black engineers employed by the city.

The private residence of John Moutoussamy also appears in this book. Moutoussamy would become the first black architect to make partner at a majority white Chicago architecture firm. And his Johnson Publishing Building on South Michigan Avenue was—and still is—the only downtown skyscraper designed by a black person.

Lee Bey and I have a lot of things in common, but none as profound as our deeply rooted love of the South Side of Chicago. Our friendship has flourished because of that shared love, but also because of our rarity among the small number of black voices who've been allowed into the mainstream conversation to talk about and be "authorities" not just on blackness but also on architecture. It is an uncommon story that black people could enter the profession of architecture and an even more uncommon privilege to write about and critique the monumental oeuvres of historically white males. Bey's voice is almost singular in this regard. He loomed large for me as I navigated my way through the ivy halls of architecture school. His name was frequently the byline on any story I could dig up about the Chicago architecture in which I was interested.

That he could also photograph architecture really well has been taken for granted for many years. This is why *Southern Exposure: The Overlooked Architecture of Chicago's South Side* is so critical to the canon and so important not just to Lee Bey's story, or to the South Side's story, but to Architecture's story. Lee says it best in his introduction, when he talks about how real estate on the South Side has often been legally stolen:

"The South Siders would've stood a better chance against a stick-up man on the street." The narrative of the South Side is much maligned, and Lee and I and many of our contemporaries in art and journalism, *we* stand up for the South Side. For South Side architecture. For South Side beauty.

Like Lee, I obsessively drive up and down the same neighborhood streets early on Sunday mornings, trying to soak in their evolution and change in real time. It's an impossible task, akin to watching paint dry (which I also attempt). Decades have been spent observing, seeing, and questioning how one city's built environment could be so uneven. These activities served as the precursor for my critically acclaimed *Color(ed) Theory* and associated photography series. I covertly painted the exterior of several vacated houses using a monochromatic color palette. The saturated hues highlighted housing segregation and economic inequities that date back to the 1930s. Lee and I are both invested in creating images that holistically narrate the entire structure and the surrounding physical and cultural context of what the viewer is seeing.

This project is not just about nostalgia but also about the *now*. These photographs reveal the essentially good bones, the formal architectural detail, character, and integrity—sometimes worn, sometimes obscured—and how those realities tell equally important stories of resilience. The architecture serves as a signifier for the people who proudly occupied the spaces—families and business owners who tried to maintain themselves and the buildings despite racism, segregation, and the systemic uneven distribution of resources and investment.

Bey's photography tells all of that and helps in the restoration and building of a counter-narrative. This work fills a void many don't even know existed. Bittersweetly,

this book becomes history in the making in and of itself; yet another first about Chicago's black South Side.

As I reflect on the intimacy and care Lee Bey has taken to document his beloved environs, I'm reminded of another Hathaway arrangement whose ethos quietly emanates from the images contained in this book, "*. . . we're alone now, and I'm singing this song to you.*"

Thank you Lee Bey, the South Side loves you back.

ACKNOWLEDGMENTS

This whole thing began, as do so many things, over coffee.

It was spring 2017, and Northwestern University Press editor Jill Petty met me for breakfast in Chicago's South Loop. "I'd like to know if you have any ideas for a book," she said.

You're now holding the answer to that question. After planting the seed, Jill then expertly guided things, talked me off ledges, pushed away a first-time author's doubt and fears, and kept the coffee flowing—earning my eternal gratitude and respect.

A host of people, perhaps more than I can ever name, also helped this book come into being. Claudette and Charles Caldwell, my big sister and brother-in-law, were a huge encouragement—along with our sister Deneterius. This book wouldn't exist without them.

I want to thank the property owners and others who granted access to me and my bulky 35mm Canon and tripod to take many of the photos in the book, especially Joanna and Shaan Trotter, owners of the Allan Miller House; Pastor James R. Bryson Jr., First Church of Deliverance; Robert Charles of Strategic Precision Management, Inc., who got me inside the Rosenwald Apartments; Mell and Angie Monroe, owners of Welcome

Inn Bed & Breakfast; Sybil L. Ingram, owner of the Dr. E. J. Ingram House; and the Rev. Luther C. Mason, Greenstone United Methodist Church.

The notion of this book began as a photography exhibit, *Chicago: A Southern Exposure*, that I created for the 2017 Chicago Architecture Biennial. A big thanks goes to DuSable Museum of African American History, the venerable South Side institution that hosted my exhibit as part of the biennial, and helped inspire the ideas and concepts expressed in this book.

I owe a debt of gratitude to the numerous Chicago scholars whose brains I've picked over the years. Roosevelt University professor emeritus Dr. Christopher R. Reed, a formidable writer and historian, turned me on years ago to the work of pioneering black Chicago architect Walter T. Bailey, an unsung talent whose designs are discussed and seen here. Also city historian Tim Samuelson and Columbia College Chicago professor emeritus Dominic A. Pacyga.

Some friends of mine must be included here. My best friend, Henry Murphy (we've been buddies since 1976), and his wife Raquel encouraged my photography at a time when I wanted to roll my camera down the basement steps and be done with it all. Noelle Critz, Stephanie S. Green, Jennifer Bridgeforth, Clinee Hedspeth, Dr. Lucille White, *Chicago Tribune* architecture critic Blair Kamin, former *Sun-Times* colleagues Roger Flaherty, Don Hayner, and Neil Steinberg, scholar Jennifer A. Scott, and attorney Quintin King also deserve a salute.

I must give a shout-out to Thomas Doyle, my senior year English teacher at Chicago Vocational High School—we still keep in touch—who told me back in 1983 that I should consider journalism as a career.

And a very special thanks goes to the Northwestern University Press team, including Director Jane F. Bunker, Managing Editor Anne Gendler, Art Director Marianne Jankowski, and Production Manager Morris (Dino) Robinson.

I wish I could give a copy of this book to my late confidant and mentor, Columbia College journalism professor Les Brownlee. As his student, I was so afraid of a job interview he arranged for me at the famed City News Bureau of Chicago that I wouldn't return the editor's calls. When word got back to the normally Zen and even-tempered Les, he angrily told me: "Man, if you don't go on that interview, I will kick your ass." A black man doesn't say that to another black man unless he aims to do it. And Les, who was in his seventies and still strapping, could do it. So I went on the interview and got the job.

Hugs to my daughters Candace, Cassandra, and Sara. They were the best of sports as they spent much of their childhood riding around the city in the back of my silver Volkswagen to explore neighborhoods, parks, and the occasional abandoned building. Those trips and their questions informed a lot of what you see in this book. I'm also thanking my paternal aunts Carmen Clark, Bertha Harris, and Beatrice Williams, whose rock-solid memories helped me shape my father's story.

I am grateful to the Graham Foundation for Advanced Studies in the Fine Arts for their support of this book.

And lastly, I acknowledge the strength, beauty, and resiliency of the South Side and its nearly eight hundred thousand citizens. You've worked hard to keep these communities together against formidable odds. Keep the faith, Baby. And keep up the fight.

SOUTHERN EXPOSURE

Introduction

The Old Man looked at me and said, "Let's go."

It was an overcast and chilly day in April of 1980. I was fourteen years old. And my father wanted to take me somewhere. Now this wasn't a trip I had asked for. I was happy enough to spend that idle Saturday just sitting around the house. But the Old Man—a Korean War vet and factory worker who could be gruff, no nonsense, and direct—had different plans. Just looked at me, maybe on an impulse, and said, "Let's go." So we went.

And soon, the two of us were gliding northward down broad Martin Luther King Drive in my father's big Buick Electra 225, rolling north past the blocks of Victorian-era graystones and large apartment buildings. The thoroughfare cuts a wide path through Chicago's historic Grand Boulevard and Douglas neighborhoods, two communities that have been the heart of black Chicago since the 1920s. The Old Man grew up in Douglas. He wanted to show me the buildings, places, and haunts of his youth.

We drove down main streets, side streets, and alleys as he showed me things. Old churches. Stately brick buildings and apartment houses. When he saw a building he particularly liked, he'd suddenly pull over and bound out of the car, motioning me to come with. "Look at those bricks," he said. "You see those windows?" Or, "There used to be a bar here when I was a kid."

Grand Boulevard, Douglas, and the surrounding neighborhoods are on the relative upswing here in the second decade of the twenty-first century, and are generally referred to as Bronzeville, or Black Metropolis, two names from the area's pre–World War II time as an economically and culturally black city-within-a-city, not unlike New York's Harlem.

The big buildings my father and I passed then can list for $600,000 or more now. But things were a lot different in 1980. Many of these great old structures were almost worthless and were vacant, or nearly falling apart. Good architecture at near fire-sale prices. The area was built for upper-class whites starting in the 1880s, when the community was essentially Chicago's first Gold Coast.[1] But those rich whites started leaving the area for what became the actual Gold Coast neighborhood just north of downtown after 1900. They packed their valises even faster beginning in the 1920s and 1930s. That's when black folks from the South started moving to Chicago and into these neighborhoods.

Among those new arrivals from the South in the 1930s was the Johnson family, led by Claudis and his wife Ohnie, both in their thirties. Among their young children was Lee, my father and tour guide for the day.

My father eased the Electra down Drexel Boulevard and took a slow pass at Fortieth Street to look at New Testament Missionary Baptist Church. The late-nineteenth-century church was an eruption of rusticated stone, marked by a triumphant four-story,

rounded-corner bell tower over its entrance. Architect George H. Edbrooke designed the place, built in 1886 as South Congregational Church when Drexel was among the city's premier addresses.[2] On that day in 1980, the church looked so old and weathered, I wondered if it was still open.

For that entire afternoon, my father introduced me to street after street, building after building. And the more he talked, the more I could see the beauty in these decayed places. He told me about the people from his youth—other black people just up from the South—who lived in the neighborhood when my father grew up there. Sam Cooke. Oscar Brown Jr. Lou Rawls and Rawls's foster father's funeral home. The places and the people became one.

I'd grown up in the back seat of that Electra, riding with my mother and father, picking up details about the city from them as the South Side metropolis of bungalows, two-flats, and church buildings unfolded before me through the car windows' light bluish-green tint. But in those cases, we were always going someplace—visiting family, picking someone up, taking my two sisters to some sort of destination. This spring day in 1980 was different. I had no idea then why he wanted me to know about these places, why it was important for him to show me. And I never asked. I just took in as much as I could and enjoyed the time we spent together.

My father died the next year. He was fifty-two.

In the decades since his death, I've come to believe that my father, with that car ride, was bequeathing to me a place he loved. Passing it on to me like an heirloom. *This is yours now.* Perhaps it had been happening little by little throughout my life as we saw places together across the greater South Side. He'd pointed out things and patiently answered my questions about the buildings I saw. Then, on that overcast and chilly

spring afternoon in 1980, he took the time to give me the last piece: the buildings and neighborhoods that made him and shaped him. The last diamond being set in that heirloom just before he handed it off to me.

Chicago's architecture is important. Its buildings are the stuff of lore, books, and architecture tours. These days, there is little evidence around town that Chicago ever butchered the world's hogs or stacked the nation's wheat, as poet Carl Sandburg famously wrote in 1914. But more than 140 years' worth of some of the finest buildings in the country are still here, and more are added constantly.

The buildings Chicago honors most are the skyscrapers that line up along Dearborn, LaSalle, and State Streets, Michigan Avenue, and Wacker Drive, designed by titans of architecture such as Holabird & Root, Skidmore Owings & Merrill, and Ludwig Mies van der Rohe. Buildings such as the Chicago Board of Trade, an art deco beauty that sweeps skyward from the foot of the LaSalle Street canyon. Or the dark and brawny Willis Tower (*née* Sears), once the world's tallest building, that punches its way through the clouds over the West Loop. And there are the twenty-first-century newcomers, such as architect Jeanne Gang's Aqua Tower, an eighty-two-story structure that looks as much a sculpture as it does a building.

The North Side's architecture is most certainly appreciated, especially the homes and buildings in the mega-monied Gold Coast, Lincoln Park, and Lakeview neighborhoods, and the miles of classy residential towers along North Lake Shore Drive.

The South Side, however, has been largely omitted from Chicago's architectural discussion.

And before we get too far along, let's define the South Side's boundaries. We're talking an area roughly bounded by Cermak Road to the north and 138th Street to the

south. The eastern border is Lake Michigan, while its western edge is an uneven and unofficial line marked by Western Avenue to the north and the city's jagged western boundaries. Within the South Side, you'll find the Near South Side, which is closest to downtown; the Southwest Side, which encompasses neighborhoods west of Ashland Avenue; the Southeast Side communities east of Stony Island Avenue; and the Far South Side, which are generally the neighborhoods south of Ninety-Fifth Street.

For decades, most of the buildings in that vast area have been flat-out ignored by the architectural press, architecture tours, and lectures—and many Chicagoans themselves. (Two bright exceptions have been the *AIA Guide to Chicago*, which covers more South Side architecture with each edition, and the Chicago Architecture Center's yearly Open House Chicago weekend. On a recent Open House weekend, about twenty-five of the 250 architectural treasures were located in predominantly black South Side neighborhoods. An additional twenty were in mostly black West Side communities. This is exactly what Chicago—and its South and West Sides—needs.)

But let's make it plain why this most egregious slight is happening: the South Side is dangerous flyover country to most outsiders, seen as a place where people are mostly black, poor, and murderous, living in squalor, disinvestment, abandonment, and violence.

And of those who come to document the South Side, far too many practice ruin porn. These are photographers who fill their Instagram, websites—and more than a few art galleries—with images of abandoned and half-demolished South Side buildings. Their photographs of these fallen structures and lost places are beautiful and macabre, like the Victorians' post-mortem photographs. Very little of this work bothers to question or challenge the larger and often racist institutional forces and policies that led

to the decline of these buildings and neighborhoods. To present these images without that narrative irresponsibly reinforces the notion that the South Side is an architectural wasteland. Nothing could be more untrue.

For instance, the aforementioned Aqua Tower won well-deserved international acclaim when it opened in 2009, but architect Gang's very nicely done Lavezzorio Community Center opened in relative anonymity in the South Side's Auburn Gresham neighborhood.

Which is too bad, because it's a fine little building that should have ridden Aqua Tower's slipstream to some modest fame, at least. Gang took a building type that often produces outright miserable and "safety minded" architecture—community centers in black communities—and created a perfect playhouse for kids. Gang gave the building a lively and unusually shaped concrete exterior, done in layers of irregular horizontal patterns of gray and white. But the shape of the facade allows it to reveal a great deal of floor-to-ceiling glass, creating a joyous, sunlit, and wonderfully transparent place where kids can gather, play, and learn. Built for just $3.5 million, with donated materials and land keeping the project affordable, the building embodies thoughtful, quality, transformative design and deserves more attention. And the center would have gotten it, had it been built on the North Side or in the booming and regentrifying South Loop. But the Lavezzorio sits at Seventy-Ninth and Parnell, in a working-class and predominantly black neighborhood. For many, this clever little building is out of sight and out of mind.

Lavezzorio Community Center, 7600 South Parnell Avenue
With its layered concrete exterior and open, kid-friendly interiors, this building was designed by architect Jeanne Gang in 2008.

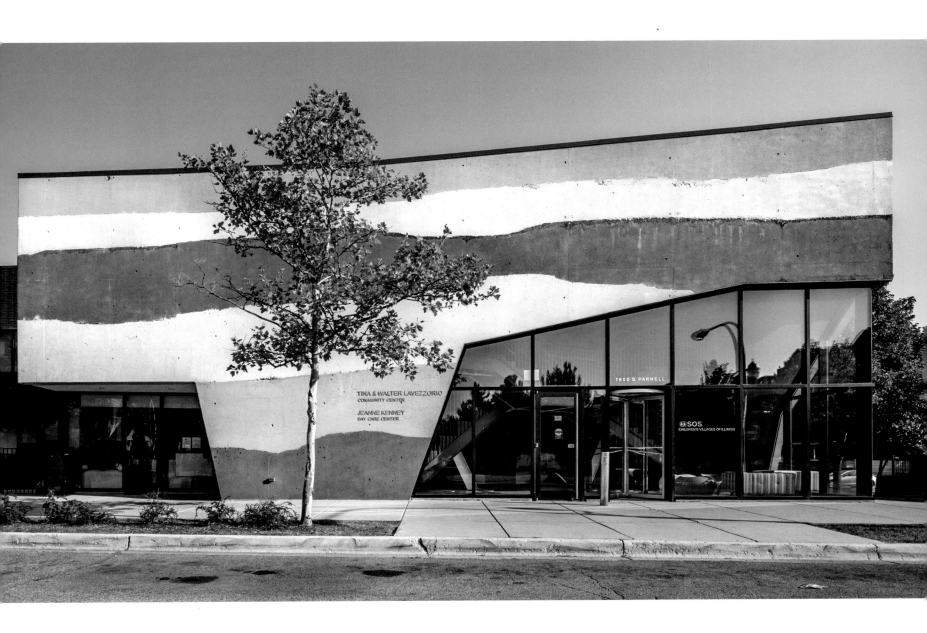

Even the South Side neighborhoods of Hyde Park and Beverly—well-planned and mostly white communities with celebrated residential architecture—are affected by this narrative. When I lived in Beverly for the first decade of the 2000s, I noticed one of the major gripes among my neighbors were other Chicagoans, particularly North Siders, repeatedly "discovering" the Southwest Side community—*"I didn't know this was here."* Beverly has been a Chicago neighborhood since 1890.

The crime and economic woes of the South Side should not be dismissed. But they can't be discussed or addressed without also mentioning how the banking, real estate, and insurance industries have cruelly conspired for decades to value homes and properties in black neighborhoods far less than those in white communities.

Nationwide, a house in a black neighborhood is worth 23 percent less than a home in a white community with similar amenities and features, a Brookings Institute study found in November 2018. Brookings found the median value of an owner-occupied house in a black Chicago-area community was $114,000. The same house in a similar white neighborhood in the region would be $151,000.[3]

According to the study, that differential over the years means untold millions of dollars in potential real estate equity—cash that could've been pulled out to send kids to college, fund businesses, climb into or above the middle class, save a residential landmark or build a future one—were robbed from property owners on the South and West Sides of Chicago. And the theft was done neatly, cleanly, and legally, with a balance sheet and a ledger. The South Siders would've stood a better chance against a stick-up man on the street.

Adding deep insult to this injury, the South Side makes up more than half of Chicago's landmass.[4] In other words, most of the city *is* the South Side, a geographic

area that's the size of Philadelphia—twice the size of Brooklyn. More than 750,000 people live on the South Side, a population rivaling that of Boston or Detroit.[5] And yet Chicago has turned its back on it—and its architecture—with relative ease.

"It's a North Side city," author and Columbia College Chicago history professor Dominic A. Pacyga told me, describing a prevailing mindset within much of the city and its leadership. "And if you're the South Side, you have two-and-a-half strikes against you already."

But the South Side matters. And its architecture deserves to been seen and protected.

That's what I learned from my father back on that day in 1980. And years later, I wound up taking up his commission. After four years as a metro desk reporter at the *Chicago Sun-Times*, I'd covered the good, bad, and ugly across the city, including the South Side. I was only thirty, but I felt like I'd covered enough shootings, crime, and misdeeds to last me a lifetime. I began contemplating a beat change. Or maybe even leaving journalism all together. Then I got wind that Nigel Wade, who was editor in chief then, wanted to start an architecture beat. So I put my bid in. And to my surprise, I got it.

At the end of my first week on the job, Nigel gave me Alan Ehrenhalt's book *The Lost City: Discovering the Forgotten Virtues of Community in the Chicago of the 1950s*, which had just been published.

"There is a place he writes about on the South Side that's called Bronzeville," Nigel said. "Does it still exist? Are the buildings still there?" Most were, I told him, but many had been demolished due to neglect and urban renewal. Nigel's response: "Read this book. Write about where this place is now."

I spent the weekend with the book. And it was as if the 1980 car ride with my father had come alive again. The places, the buildings, the histories that he showed me—and that I'd barely considered since, even though I passed through the neighborhood frequently—it all came back. And from 1996 into 1997, I wrote pieces advocating for the preservation and restoration of historic Bronzeville buildings and the neighborhood overall. The area's black residents whispered, yelled, cajoled, and fought for Bronzeville's restoration, as they had for years. Part of my job was to amplify their voice.

1 Saving Bronzeville

Bronzeville is Chicago's Harlem. But as Harlem began its renaissance in the 1990s, Bronzeville was largely the same grand but decaying neighborhood my father and I drove through more than fifteen years earlier. New York City began investing in Harlem and positioning it as the true historic and architectural asset that it is, but Chicago largely let Bronzeville languish. Chicago and its boosters are always claiming the Windy City is just as good as the Big Apple, or better. Saving Bronzeville would have been an equitable and meaningful way to prove it—but Chicago wasn't just striking out; it wasn't even attempting to swing.

During the first half of the twentieth century, Bronzeville was a major destination of the Great Migration, as between six and seven million black people said good riddance to the racist neo-feudalism of the South—along with the state-sanctioned brutality that supported it—and sought better lives in jobs-rich, and theoretically Jim Crow–free, northern industrial cities like Chicago.[1]

"Six million people flee the American South and they go to Cleveland and Chicago and Detroit and Los Angeles and Oakland—not as immigrants, but as refugees and exiles from terror in the American South," Bryan Stevenson, social justice activist, attorney, and founder and executive director of the Equal Justice Initiative in Montgomery, Alabama, told me.[2]

More than five hundred thousand black Southerners settled in Chicago, brought in by rail lines such as the storied Illinois Central.[3] A black person or an entire family could turn their back on a life of menial and laborious work picking cotton or as an overworked domestic in a white Southern household, board an Illinois Central train in the deepest South—in Mobile, Alabama, or in Natchez or Jackson, Mississippi—and disembark less than a day later at the Illinois Central's massive Romanesque Revival passenger terminal at Roosevelt Road and Michigan Avenue on the southern edge of Chicago's shimmering and modern downtown.

The message was unmistakable for a black person, in theory at least: in the second largest city in America (by the mid-twentieth century) and the eighth largest metropolitan area in the world, there is a place and a job for me. Fuck the South.

At least 90 percent of African Americans lived below the Mason-Dixon Line in 1910. Only 53 percent remained when the Great Migration ended in 1970.[4]

Black people searching for new lives in the North changed the face of America. From its small corner of the South Side, Bronzeville left its mark on nearly every aspect of American life. The likes of singers and musicians Louis Armstrong, Dinah Washington, Nat King Cole, Quincy Jones, Sam Cooke, and others sharpened their young chops in Bronzeville's clubs, halls, cafés, and churches before ultimately finding their place on national and world stages. Bronzeville sent the first black congressman elected from

a northern state to Washington, D.C. Black soldiers and commanders stationed in Bronzeville helped liberate France from the Germans in World War I.

Bronzeville was the home of the *Chicago Defender*, the pioneering black newspaper that became a national voice in the fight against black oppression in the South, while sounding the call to its black Southern readers that sparked the Great Migration.

You could become a whole new person in Chicago. My paternal grandfather, Claudis, even found a new religion and name. After arriving in Chicago and getting a job laying sidewalks for the Works Progress Administration during the Great Depression, he joined the Moorish Science Temple of America, a then new religion very loosely based on Islam and started in New Jersey by a black man named Noble Drew Ali.[5] The Moorish Science Temple gained adherents in black areas of Great Migration cities such as Detroit, New York, and Chicago, who were drawn to its tenets, which included racial pride and uplift. Followers would often drop their surname in favor of an Arabic one, such as Ali, El, or in the case of my grandfather, Bey.

My late mother, the former Lula Dixon, moved to Chicago from Helena, Arkansas, as a young adult in the early 1950s. "There was nothing there," she would say to me about Helena when I asked about her hometown as a kid. "Nothing." She and her two older sisters, Alice and Geneva, were among the Great Migration's second wave that came after World War II. Many of these later arrivals settled on Chicago's West Side, my mother and aunts included. My mother and Aunt Geneva both found jobs at the Spiegel, Inc., headquarters and catalog house on Thirty-Fifth Street, a little more than a mile west of Bronzeville. At the time, the South Side merchandiser did $200 million a year (about $1.6 billion today) in mail-order business and was one of the biggest private employers in the city.[6]

"It was pretty good money at that time," my aunt Geneva Allen, now in her nineties, remembers more than sixty years later.[7]

Bronzeville's architecture was brick-and-mortar proof of an incredible story of black self-determination and advancement. But by the 1980s and 1990s, the neighborhood's most important landmark-quality buildings were either at risk, or already demolished.

For instance, the National Pythian Temple, a remarkable eight-story art deco corner building at Thirty-Seventh and State Streets, built in 1927 by the Knights of Pythias, a black fraternal order, was wrecked in the early 1980s.[8] Gone was an excellent building designed by Bronzeville resident Walter Thomas Bailey, the state's first licensed black architect.[9] The temple had offices, a drill hall in the basement, a first-floor auditorium that sat 1,500, and a rooftop garden.[10] It was a major building on Bronzeville's State Street, a thoroughfare so packed with African American–owned banks and retail businesses by the 1930s and 1940s that it had been dubbed the city's "Black Wall Street." The Pythian Temple was the skyscraper of Black Wall Street.

Bailey gave the building a terra-cotta facade detailed with ranks of pharaohs, symbols, Egyptian figures—even depictions of Cleopatra.[11] The building was designed during the height of the Egyptian Revival architectural craze, sparked by the discovery of King Tut's tomb in 1923, but Bailey and the Pythians were doing something more sophisticated than latching on to a hot architectural trend. They used architecture and design to stake a claim to the history and people of Egypt, a place viewed by many—even today—as separate from "black" Africa and Africans.

The Pythians claimed that the temple, with a construction cost that approached $1 million, was the largest, most expensive building ever designed, built, financed,

and owned by American black people.[12] True or not, the distinction couldn't save the building. After being converted to apartments after World War II, the temple fell into disrepair. Families started moving out in 1978 when the blind trust that owned the structure stopped paying the building's utilities, including a $3,622 water bill to the city.[13] The building was demolished a few years later, without as much as a public peep from the city's active preservation community.

The temple as a building was unwanted, but that was not the case for its ornate golden terra-cotta skin. Salvaged sections found their way into the hands of collectors[14] and museums, including the city's Chicago History Museum—on the city's North Side of all places.

There were eight surviving Bronzeville buildings of equal, if not greater, historic and architectural importance than the Pythian Temple in the 1990s. But they were almost all vacant—decaying and hanging on by the slenderest of threads. The eight sites and a war monument had been placed on the National Register of Historic Places in 1986 as part of an earlier effort to create the Black Metropolis Historic District. The thematic district was an attempt to use the neighborhood's storied past to lift it out of the economic mire and honor its black heritage.[15]

The buildings were the Overton Hygienic Building at Thirty-Sixth and State Streets; the Chicago Bee newspaper building, located on the same State Street block as the Overton; the original Chicago Defender Building at Thirty-Fourth Street and Indiana Avenue; the Wabash YMCA at Thirty-Eighth Street and Wabash Avenue; Unity Hall, at Thirty-First Street and Indiana Avenue; the Supreme Life Building, at Thirty-Fifth Street and King Drive; the former Sunset Cafe, located on Thirty-Fifth Street about a block west of Supreme Life; the old Eighth Regiment Illinois National Guard Armory

at Thirty-Fifth Street and Giles Avenue; and the Victory Monument standing in a median on Thirty-Fifth Street and King Drive, erected in honor of the black troops and commanders from the Eighth Regiment who fought in France during World War I.[16]

Bronzeville residents and preservationists worked with the administration of Mayor Harold Washington, the city's first black mayor, and advocated for landmark-status listing for the buildings and monument. But Washington died in office in 1987, and over the next decade, under the administration of Mayor Richard M. Daley, the city did next to nothing to honor promises to protect and redevelop the area.

If there were ever an example of how South Side architecture is devalued and dismissed, the case of Bronzeville was it. The Daley administration began pouring hundreds of millions of dollars in redevelopment funds into downtown and North Side neighborhoods in the 1990s—while it seemed poised to wreck Bronzeville's historic buildings. The city had demolition cases against seven of the eight Bronzeville buildings listed on the National Register. Then the administration virtually ratified this tactic by dragging its feet on granting the buildings protected city landmark status, which would have made it almost impossible for anyone to get city approval to raze the buildings—including the city itself.

Paula Robinson, president of the Bronzeville Community Development Partnership, was a leader in efforts to create and preserve the Black Metropolis Historic District buildings beginning in the mid-1980s. She says their goal was larger than sparing the buildings from demolition. The community wanted to work with the city to get the structures preserved and reused.

"Oftentimes, the preservationists [in white communities] say, 'So-and-so is the

architect, and this building is part of our heritage and we want it saved,'" Robinson says. "But we can't stop there. For us, there has to be reuse. Everything has to have a purpose, a cash flow, a revenue stream. Saving it, but as what? It's got to have an adaptive reuse strategy. And that was often a challenge for us."[17]

But even when there was a reuse plan for one of the eight Black Metropolis buildings, the going was still rough. Take for instance, the Wabash YMCA—dubbed the "Colored Man's Y"—a collegiate-looking, four-story brick structure from 1911, designed by Robert C. Berlin.[18] Black scholar Dr. Carter G. Woodson founded what is now the Association for the Study of African American Life and History during his stay at the Wabash Y in 1915, and the association in 1926 created what is now Black History Month.[19] Mayor Richard M. Daley kicked off Black History Month 1996 in a City Hall ceremony honoring the historic Colored Man's Y and an effort by a group of Bronzeville churches to rehab and reopen the shuttered facility as a center for housing, educational services, and employment training.[20] But as Daley praised the building's history and the churches' work, he never mentioned that his administration was also in demolition court seeking to turn the historic structure into a pile of rubble.

Had the city been successful, a building that was a key player (not to mention a handsome piece of architecture) would have been lost. During the Great Migration, the Y hosted classes and activities that acclimated the new Southern arrivals to big-city life. The all-black Savoy Big Five basketball team played in the building's gym in the 1930s.[21] When an internal dispute broke up the team, several of its members formed a new squad called the Globe-Trotters. The team added "Harlem" to their name (and dropped the hyphen) and fancy-dribbled to worldwide fame.[22]

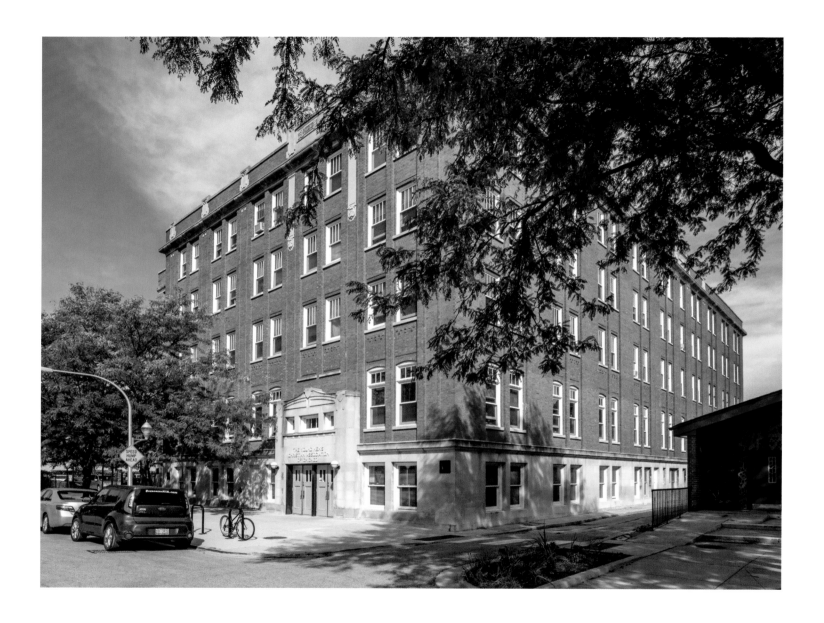

had grown to maturity through the drill hall's wooden floor—was saved, given a $20 million rehab, and reopened after almost fifty years as the Chicago Military Academy–Bronzeville, a public high school. U.S. Secretary of the Army Louis Caldera attended opening day ceremonies in 1999.[27]

The Overton Hygienic Building now functions as an office building again after receiving a well-done exterior restoration in 2007 as part of a more than $8 million rehabilitation funded by private equity and Historic and New Market tax credits. The Overton's neighbor, the Chicago Bee Building, has been a popular public library branch since 1996. Visitors and passersby alike stop to gawk at the building's emerald-colored terra-cotta face.

Also back in business is the former Supreme Life Building, which today hosts a variety of small offices and nonprofits, thanks to a $4 million restoration in 2006 by Piekarz Associates.[28] A pleasant surprise: construction crews peeled off the Supreme Life's light-blue porcelain-enameled stainless-steel cladding—it had been slapped on in the 1950s in a bid to make the building look more modern—and found architect Albert Anis's original light-colored Georgian Revival exterior still standing pat underneath.

The Sunset Cafe remained in use as Meyer's Ace Hardware, with the owners keeping up the Jazz Age murals—reminders of the building's original life—in the rear of the store. The hardware store closed in 2017, and the owners haven't announced plans for the building. But they have publicly declared their intention to preserve the murals.[29]

Eighth Regiment Armory/Chicago Military Academy, 3519 South Giles Avenue
This historic Bronzeville armory, built in 1915, was once home to black soldiers who helped liberate France in World War I. It is now a public high school military academy.

Unity Hall's fate seemed uncertain almost twenty years after receiving city landmark status. Built in 1884, Unity is the oldest of the group. The three-story brick building, with a trio of Victorian dormers set two stories above its arched entrance, began life as a Jewish social club. But it made history in its second incarnation as the all-black Peoples Movement Club, the social and political headquarters of Oscar Stanton De Priest, the city's first black alderman. The black political base, electoral muscle, and influence De Priest marshaled there—turning Great Migration arrivals into northern Republican voters—made him a major player in the city's white and then largely Republican machine. And it propelled him to Washington, D.C., in 1929 as the first black person elected to Congress from a northern state.

Incidentally, the Moorish Science Temple of America held its first national convention at Unity Hall in October 1928.

Unity Hall sat on the critical list, even as other Bronzeville landmarks were being brought back to life in the late 1990s and into the 2000s. Things got so bleak, the organization Preservation Chicago placed Unity Hall on its list of the city's most endangered buildings in 2012. Help finally arrived in 2015, when this important building was rehabbed and converted to student and affordable rental housing.

The old Chicago Defender building remains vacant, awaiting a new use. But at least it stands.

As for the Colored Man's Y, the Daley administration slowed its efforts to raze the Y once my *Sun-Times* stories in 1996 brought the demolition case to light. The building

Welcome Inn Bed & Breakfast, 4563 South Michigan Avenue
Owners Mell and Angela Monroe relax in a den in their B&B.

was even granted city landmark status in 1998. The once-derelict building today is the Renaissance Apartments, complete with programming and a fitness center.[30]

There's even a top-rated bed-and-breakfast in Bronzeville now, the Welcome Inn B&B, inside a nicely restored 1893 brick-and-stone corner mansion at 4563 South Michigan Avenue.

It's an outrage to think these historic assets just as easily might have been torn down or left to deteriorate to the point where they could have collapsed on themselves,

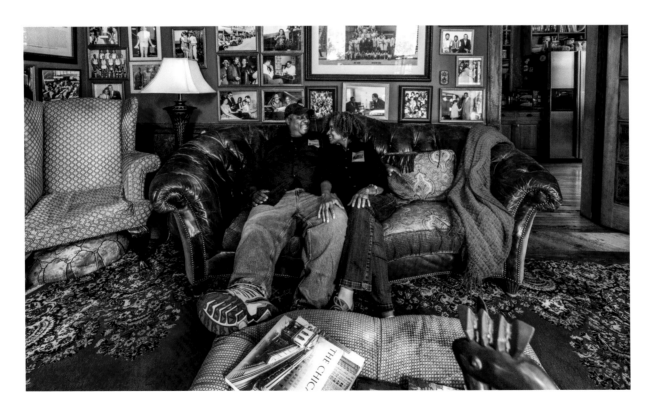

Amazingly, virtually all of this was completed without a formal city master plan.[7] While the Chicago Plan of 1909—the Burnham Plan—shaped the city's downtown, it had little impact out in the neighborhoods, except for generally supporting the creation of parks and wide boulevards. In the neighborhoods outside of downtown, developers, landowners, and industry together provided the spark that led to the communities' formation, urban form, and architecture. Substantial, well-designed homes, streets, schools, parks, and open spaces were fundamental.

For instance, developer Frederick H. Bartlett built huge portions of the South Side during the first two decades of the twentieth century. A 1909 newspaper ad touted his Hamilton Park subdivision, located around Seventy-Third and Halsted in the Englewood neighborhood, as the city's finest subdivision, with its wide, forested streets and proximity to both twenty-nine-acre Alexander Hamilton Park, built in 1904, and the Rock Island train line, which could bring commuters downtown in less than twenty minutes. "I am more proud of the Hamilton Park subdivision than I am of any of the properties I have ever developed," Bartlett said in a handwritten signed testimonial accompanying the ad.[8]

Now, let's not get too romantic about this. Governmental laissez-faire and urban planning by the 1 percent class gave the South Side great-looking neighborhoods . . . and created pockets where some of the worst slums in America existed. Portions of Bridgeport, the South Loop, the Back of the Yards neighborhood next to the mammoth Union Stock Yards, and the emerging Black Belt contained densely populated areas with deplorable living conditions, near-shanties, open sewers, and little or no plumbing.

In addition, there were no fair housing laws then, so developers were free to prevent anyone who wasn't a white, Anglo-Saxon Protestant from living in these

new communities. "We have nothing but the best people in this special high grade subdivision," Bartlett says in his Hamilton Park ad, "and we must know that you are like them or we will not sell to you."

Paul Cornell also envisioned a South Side neighborhood with green space, open spaces, and gracious housing. He bought three hundred acres of land in the new and growing South Side lakefront community of Hyde Park in 1853. Then, in a pretty wily move, Cornell gave sixty of those acres to the Illinois Central Railroad. Of course the railroad built a train station on the donated property at what is now Fifty-Third Street and Lake Park Avenue—clearly what Cornell wanted, giving the area direct rail access to downtown—which increased the value of Cornell's land and in turn called for attractive, well-planned architecture.[9]

The University of Chicago was founded in Hyde Park just west of the lake in 1890, a year after the big annexation. The university's first building, Silas Cobb Hall, a four-story lecture hall dripping in Gothic Revival detailing, was completed at Fifty-Eighth Street and Ellis Avenue in 1892. Architecturally, the building designed by noted Chicago architect Henry Ives Cobb (he wasn't related to Silas) was a slice of England's University of Oxford, replicated and set down on the South Side.[10] The hall was also the bellwether of how University of Chicago buildings would look for the next sixty years.

Then came the famed 1893 World's Columbian Exhibition. The heart of the fair was six hundred acres of pearly white buildings and pavilions located in newly built Jackson Park, along the lake. The fair buildings and grounds mimicked the best of Greek, Roman, and French architecture and design: pediments, columns, and porticos laid out around man-made lagoons, green space, and broad walkways. The Porch of Maidens at the Palace of Fine Arts replicated the Porch of the Caryatids at the Erechtheion,

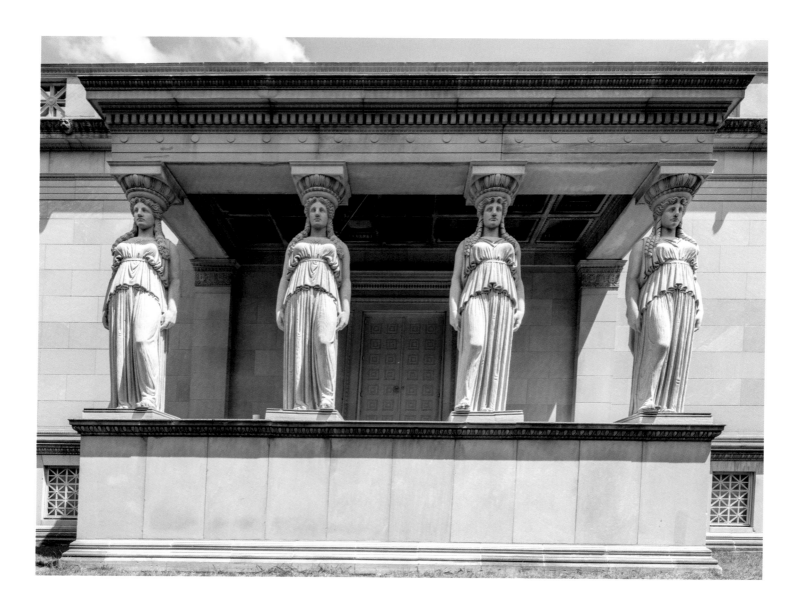

which was built in 421 B.C. on the Acropolis in Athens.[11] The robed maidens still act as columns on both buildings; the Erechtheion still stands in Greece, as does the Palace of Fine Arts building at Fifty-Seventh Street and Lake Shore Drive. The temple-like edifice was the first home of the Field Museum of Natural History, from the close of the fair until 1920. It spent years vacant and in sorrowful condition until philanthropist and Sears president Julius Rosenwald funded and led efforts to renovate the building and convert it in 1940 to the Museum of Science and Industry.

The new Armour Institute of Technology opened its Main Building in 1892 at Thirty-Third and Federal Streets on the western edge of the Douglas community. Designed by Patton & Fisher, the building is a four-story essay in Romanesque architecture, gracefully written with red brick and bountiful arches.[12] The building and its smaller, similarly designed sibling Machinery Hall, from 1901, still stand side-by-side today, but they are largely overshadowed by the modernist buildings, designed mostly by Mies, that would roar onto the campus beginning in the late 1940s.

Two of the nation's most extraordinary examples of the era's industrially planned and executed architecture sit as bookends on the South Side. They are the Central Manufacturing District on the north end, where the South Branch and abundant rail lines once formed an economic golden bow, and the former industrial town of Pullman on the far South Side, nestled between Lake Calumet and what once was the Illinois Central Railroad line. The Central Manufacturing District (CMD) was America's first planned industrial park. Pullman was the country's first planned industrial model town.

Porch of Maidens, Museum of Science and Industry, Fifty-Seventh Street and Lake Shore Drive

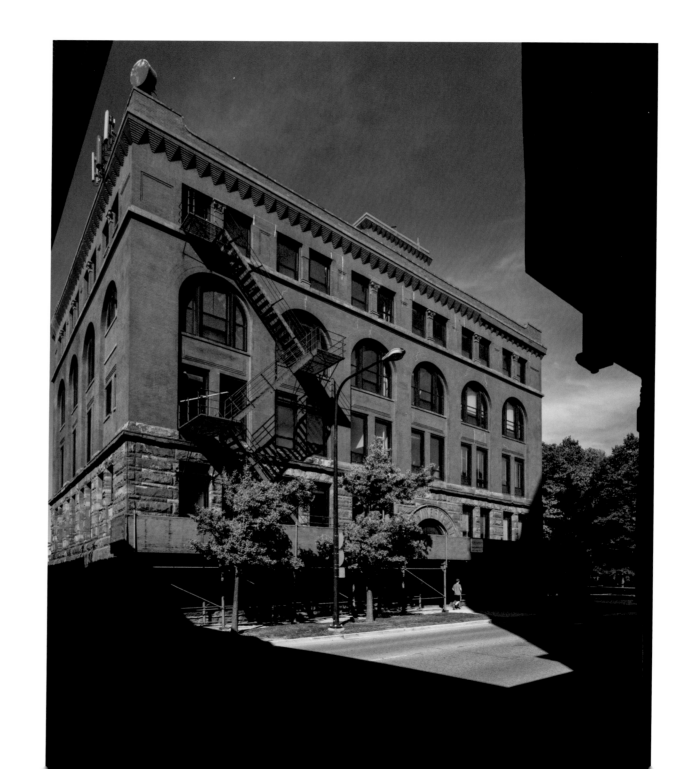

Illinois Institute of Technology Machinery Hall, 100 West Thirty-Third Street

Opposite: Located just north of the old Main Building; the two structures together formed the core of the Armour Institute of Technology, which was the forerunner to IIT.

Illinois Institute of Technology old Main Building, 3301 South Federal Street

Above: With its red brick and pronounced arches, this Louis Sullivan-esque building, built in 1892, was designed by architects Patton & Fisher.

Built in 1905, the Central Manufacturing District at its height sat on 265 acres bordered by Thirty-Fifth Street and Pershing Road (Thirty-Ninth Street), and Morgan Street to Ashland Avenue. Located in the city's McKinley Park neighborhood, the district was home to two hundred businesses and manufacturers. The brick and terra-cotta buildings were designed in a variety of styles, including Prairie, art deco, and late Gothic Revival. The CMD's in-house architecture bureau worked with businesses on building detailing, massing, and entrances, achieving a subtle design consistency throughout the district.[13]

Architecturally, the district's buildings were largely an industrialized take on Arts & Crafts design—with maybe a pinch of Gothic Revival—which gave the brick and terra-cotta structures a definite visual worth and beauty. The architecture also signaled that the CMD was a high-end effort that could attract the likes of chewing gum manufacturer William Wrigley & Co., Westinghouse Electric, and catalog retailer Spiegel & Co. The district had its own bank, executive club, and telegraph office—not to mention its own police force, traffic bureau, fire department, railroad lines, and, in its early years, an in-house bureau of architecture. Goods moved above ground and also through a network of underground tunnels.

A 240-page book filled with crisp black-and-white architectural photographs of the district, published by the CMD in November 1915, touted the structures as "a most substantial, attractive and practical class of buildings."[14]

Central Manufacturing District Tower, 2000 West Pershing Road

Created in 1915 as the nation's first planned industrial district, the CMD features an enviable collection of high-quality warehouse and factory buildings, including this brick and terra-cotta tower.

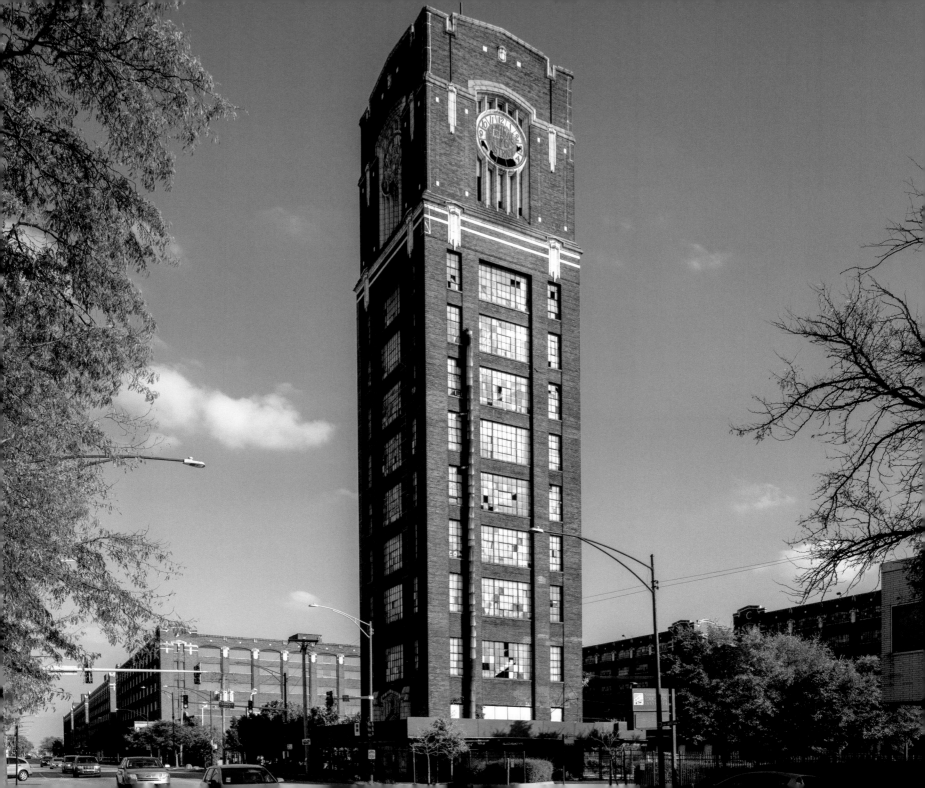

The CMD found itself at capacity by 1915. So the district expanded westward on Pershing Road from Ashland to Western Avenues, tacking on a mile of larger, but still impressive-looking, brick and terra-cotta industrial buildings.[15] The CMD is largely empty today, and several of the buildings in its western addition have been demolished. The vacant four-story former Pullman Couch Factory building at Thirty-Seventh Street and Ashland Avenue was demolished after nearly burning to the ground in 2010. For almost two days, Chicago firefighters wrestled with the five-alarm blaze in ten-degree—and colder—weather. News footage and photos of the great warehouse shrouded in thick ice were broadcast around the world.[16] The Chicago Department of Planning and Development is shopping around the western addition for possible reuse. The big site contains an iconic twelve-story tower—a beauty in brick, glass, and terra-cotta detailing. Reuse would be a boost to the predominantly Latino neighborhood.

By the way, McKinley Park sits across Pershing Road from the CMD addition. Built in 1906, the seventy-acre park is a jewel of the Progressive Era; the green space was designed to provide social services alongside traditional parks offerings. Not a bad idea at the time, given that the park was located in a working-class, hardscrabble area near the Back of the Yards and Brighton Park neighborhoods.[17]

While the CMD's fate is up in the air, things are more grounded on the other end of the South Side in the Pullman neighborhood. The heart of the community is a late-nineteenth-century former company town, factory building, and hotel, all built by industrialist George M. Pullman to manufacture his luxurious Pullman Palace railroad sleeping cars—veritable hotels on wheels that brought comfort and ease to

transcontinental railroad travel in America and across the world. The self-contained model town was built solely for his bosses, factory workers, and their families. And Pullman charged them rent to live there.

George Pullman created a remarkable place. The town center was the Pullman Palace Car Co. factory and administration building. With its clock tower rising above town, it looked more like an 1880 city hall building than an industrial complex. Lake Vista fronted the building and completed the conceit: the small pastoral lake was man-made, built to provide a water source to cool the massive, 2,500-horsepower Corliss steam engine that powered the factory's train-making machinery.[18]

Architect Solon S. Beman designed the entire town and its buildings. The town is predominantly rowhouses, with Beman designing larger dwellings closer to the factory and hotel for the company's bosses. Workers' cottages got smaller the farther they lived from the factory. The town has its own church. Back in Chicago, a laborer and his family could find themselves living in squalid conditions in near-shantytowns. But not in Pullman. Here, every worker lived in a neat brick home that faced solid brick streets with tree-lined parkways and small front yards. Inside there was plumbing and a kitchen with a stove—even in the most humble rowhouse.

The architecture was set against a backdrop created by landscape architect Nathaniel Barrett, who gave the town the look of a formal European garden with geometric flowerbeds bursting with a colorful variety of plantings: marigolds, geraniums, flowering annuals, and more. Barrett's plan called for a bountiful thirty thousand trees and one hundred thousand plants. Teams from the Pullman Company maintained the generous landscapes.[19]

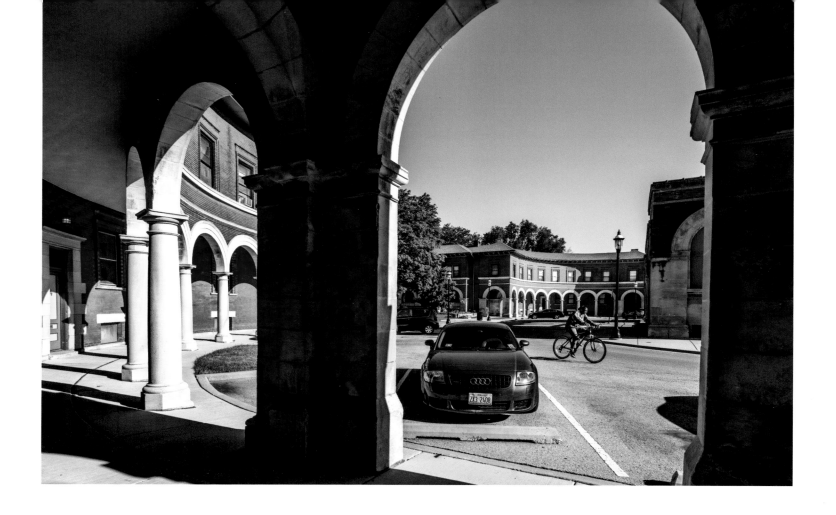

Pullman Colonnade Apartments, 112th Street and Champlain Avenue

Built in 1893 in the heart of the Pullman neighborhood, four curved and colonnaded two-story apartment buildings surround the former Pullman Market Hall, where produce and bread were once sold.

Opposite: This duplex, designed by Pullman town architect Solon Beman, is one of four look-alike brick-and-limestone residences, each paired with one of the Colonnade Apartments buildings.

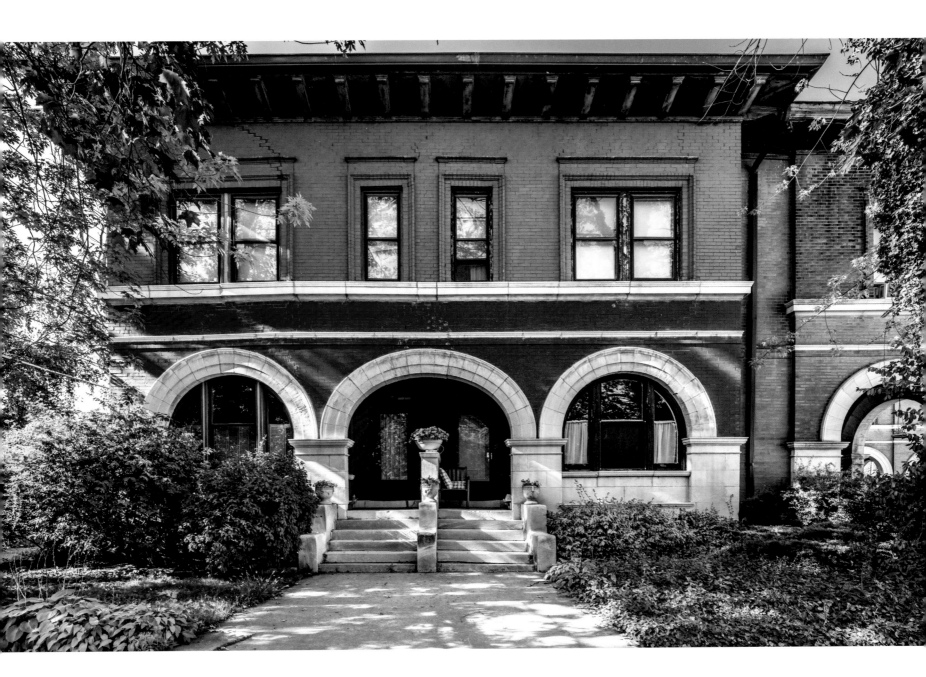

Pullman wasn't an entirely new idea. In England, Sir Titus Salt completed Saltaire, a model workers' town and textile mill on the outskirts of Bradford, West Yorkshire, in 1876. Like Pullman, the Italianate-designed village had a church, park space, a library, a school, and a hospital along with the mill and workers' housing. Unlike Pullman, the homes had outside toilets. There were also no bathrooms, so Salt built public bath houses for his workers instead.[20]

The state supreme court forced the Pullman Palace Car Co. to sell off the residential portions of the town in 1898 as part of the resolution of the Pullman workers' strike. (The workers struck when the Pullman company cut factory wages, but refused to reduce rents and prices in Pullman.)[21] Once sold, the town's streets, parkways, and sidewalks were the property of the city of Chicago, which had annexed the community in 1889.

Incidentally, Pullman birthed a similar venture about two miles west. Inspired by the town of Pullman, the West Pullman Land Association formed in 1891. The group of high-powered businessmen and industrialists bought up 480 acres—plopping down $2,500 an acre, which would be at least $65,000 an acre today—of small towns, farms, and undeveloped land bounded by the Illinois Central Railroad tracks, Ashland Avenue, 115th Street, and the Calumet River, and turned it into West Pullman, an orderly and well-planned industrial and residential city-within-a-city of twenty thousand. West Pullman had major factories for businesses such as International Harvester, Dutch Boy Paints, the Opaque Shade Cloth Company, and others. The factories were substantial in size. The Plano Manufacturing Company plant boasted fifteen acres of floor space.

Greenstone United Methodist Church, 11211 South Street and Lawrence Avenue
This 1882 church is one of the few original Pullman buildings that isn't made of red brick. Pullman architect Solon Beman instead selected green serpentine limestone quarried in Pennsylvania.

Handling urban planning duties, the privately owned and funded West Pullman Association set aside space for schools, parks, and retail, plus a hierarchy of homes priced for everyone from workers to executives.

Planners created the then upscale Stewart Ridge subdivision in the northernmost section of the area, between 121st and 123rd Streets and Wentworth and Normal Avenues. It had its own commuter train station—it still does—providing rail access to downtown Chicago. The subdivision featured wide lots and larger homes, often designed in stately revivalist styles.

One exception was the S. A. Foster House and Stable at 12147 South Harvard Avenue, a summer residence designed by Frank Lloyd Wright for the land association's vice president and treasurer, attorney Stephen A. Foster. The home was built in 1900 when Wright's famed Prairie School period was going full swing, but the architect abandoned the style here, designing a frame house with overtly Japanese influences—particularly seen in the home's flared dormers and the pagoda-like details atop its entry gates. The home still stands today, unrestored but decently maintained. It was also for sale in 2018 and lingering on the market at $180,000—the cheapest Frank Lloyd Wright listing in America. As I photographed the house for this book, the listing agent even let me in on a secret. "I've got a drop-dead price of $175,000," she said. "If you could spread the word."

West Pullman was built for white people, and its land association, residents, and companies worked to keep it that way. Factories refused to hire black workers until World War II, when the federal government forced desegregation as a condition of awarding the industries their war production contracts. On the real estate side,

Stephen A. Foster House and Stable, 12147 South Harvard Avenue

Designed by Frank Lloyd Wright, the residence was built in 1900 as a summer house for a Chicago attorney.

restrictive covenants were enforced, allowing white homeowners to legally refuse to sell to black people until nearly 1950. (This was the case in many Chicago neighborhoods, including the alleged liberal bastion of Hyde Park, where it was strictly enforced by the University of Chicago, the community's largest single property owner.) By 1980, the familiar tableau had played out: the neighborhood became nearly entirely black and its once mighty cluster of industries slowly vanished. Today the neighborhood struggles with high unemployment, crime, and home foreclosures, but many of the residents are holding on, taking good care of the better homes in the area, despite a lending market that often works against them. The S. A. Foster House is a bargain for a Wright-designed house, but it's tricky to finance conventionally in a neighborhood where homes in 2018 could be found for as low as $30,000.

But back to the old town of Pullman, which today is a largely intact historic and architectural treasure. The part of Pullman that sits just south of the factory—bounded by 111th and 115th Streets, the Bishop Ford Expressway, and the Illinois Central (now the Metra Electric commuter rail) embankment—has been so lovingly maintained, walking its streets is almost like taking a step back in time. In addition to the homes, the chalet-like former Hotel Florence still exists on the southeast corner of 111th Street and Cottage Grove Avenue. State-owned since 1990, the building is being renovated and awaits reuse.

The part of Pullman that lies north of the factory had been a trouble spot for decades, with foreclosed, vacant, and dilapidated housing. But now things are turning around. Since 2013, Chicago Neighborhood Initiatives, a regional nonprofit community redevelopment organization based in Pullman, has been actively purchasing, rehabbing, and reselling the homes at affordable prices north of $100,000. New industry—which means jobs—have started to return to Pullman, including a $30 million factory for

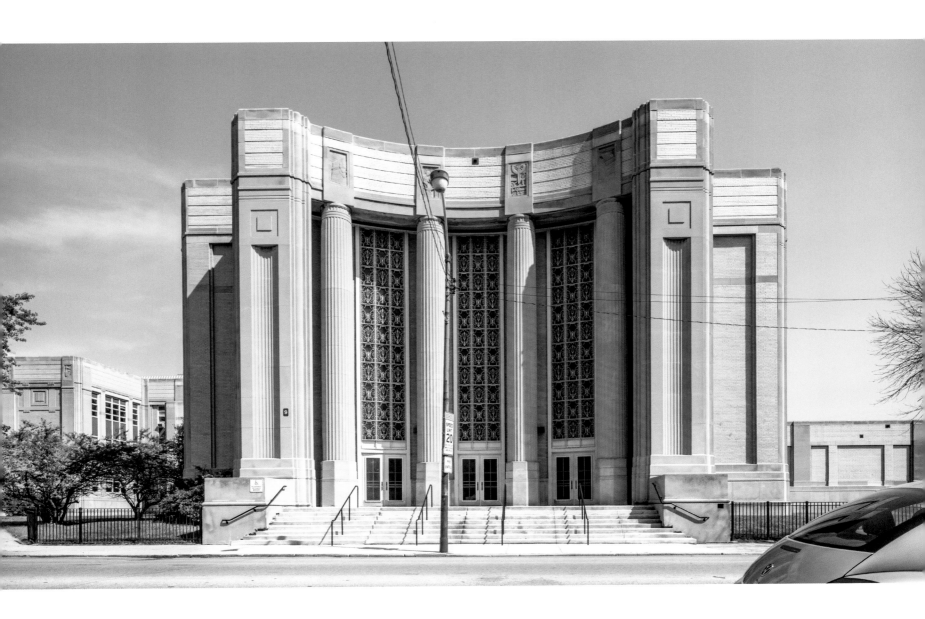

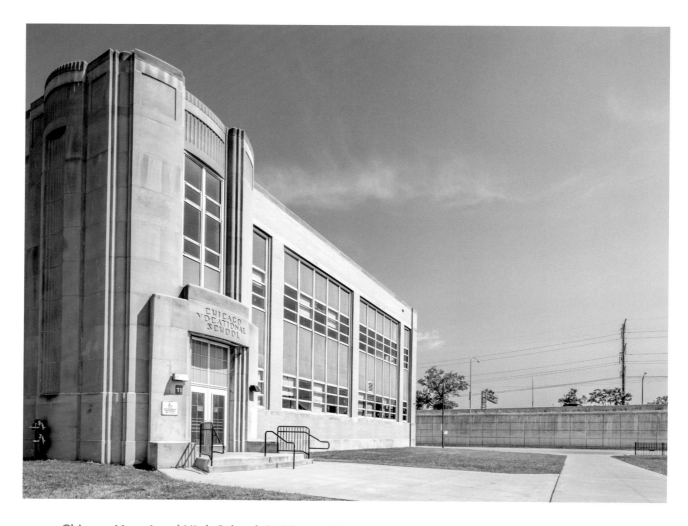

Chicago Vocational High School, 2100 East Eighty-Seventh Street

The exterior of a former shop class resembles a mini factory, consistent with the school's original vocational theme.

Opposite: This view shows the school's main wing and front entrance. An expansive lawn separates the building from busy Eighty-Seventh Street.

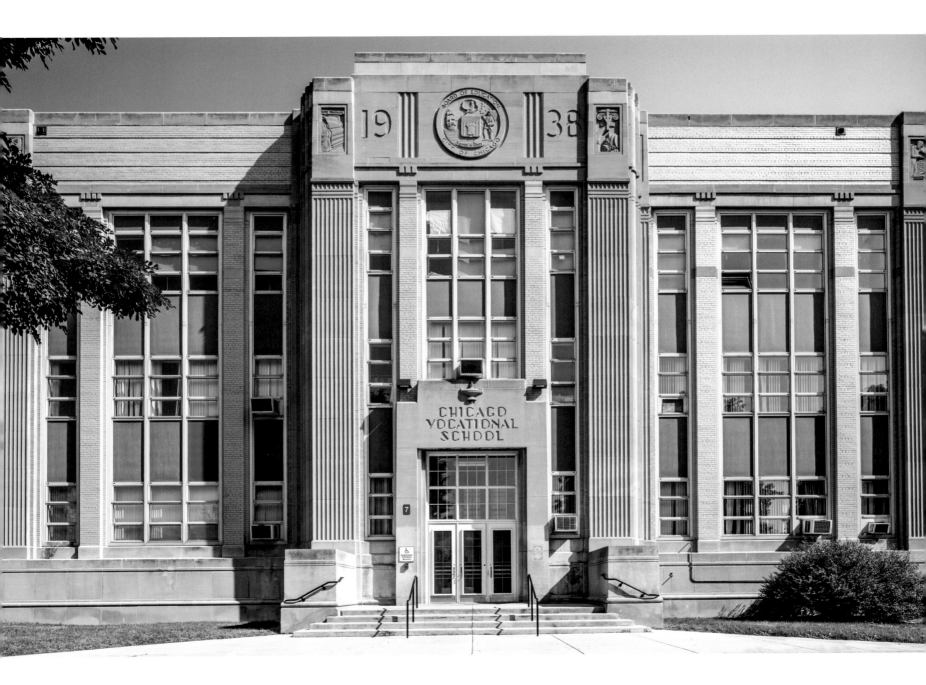

But here is what can happen when a landmark-quality building is not protected as one, and sits on the South Side, out of view of the city's influential downtown and North Side–based preservation groups. To make space for a building addition that would house the new curriculum, a portion of a former shop wing along Anthony Avenue was considered for demolition—without any outside review—to accommodate the new classrooms and equipment spaces. It would have been a loss if it weren't for the school's overall sheer size. But it's a reminder the school needs protection and attention.

When I was a Chicago Vocational student in the early 1980s, our rival was James H. Bowen High School, located a few blocks away at 2710 East Eighty-Ninth Street. It wasn't at all uncommon to find us squabbling—and sometimes out-and-out brawling—with each other on the streets between the two schools. What were we beefing over? Girls? Bragging rights? I have no idea now. We were the CVS Cavaliers and they were the Bowen Boilermakers (the nickname for a type of welder in a steel mill, not the drink) and that was enough. We should've just called a truce and marveled at how beautiful our school buildings were.

Built in 1910 and designed by Dwight Perkins during his term as chief architect of the school system, Bowen is a remarkably beautiful Prairie School building with duo-tone brickwork and radically overhanging gable roofs. It's a big building, part of a sprawling campus, yet it somehow doesn't overpower the residential neighborhood of two- and three-story buildings in which it was built.

Bowen High School would be a city landmark and on the National Register if it were located on the North Side. And that's not empty talk. The North Side's Carl Schurz

James H. Bowen High School, 2710 East Eighty-Ninth Street

This handsome brick Prairie School building—albeit obscured by sketchy-looking trees and landscaping—was built in 1910 and designed by famed architect Dwight Perkins.

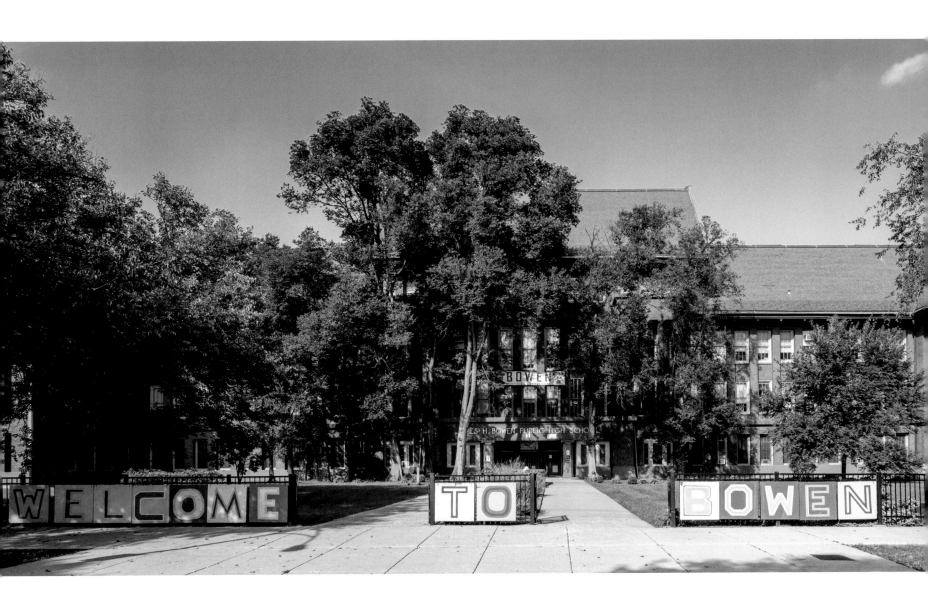

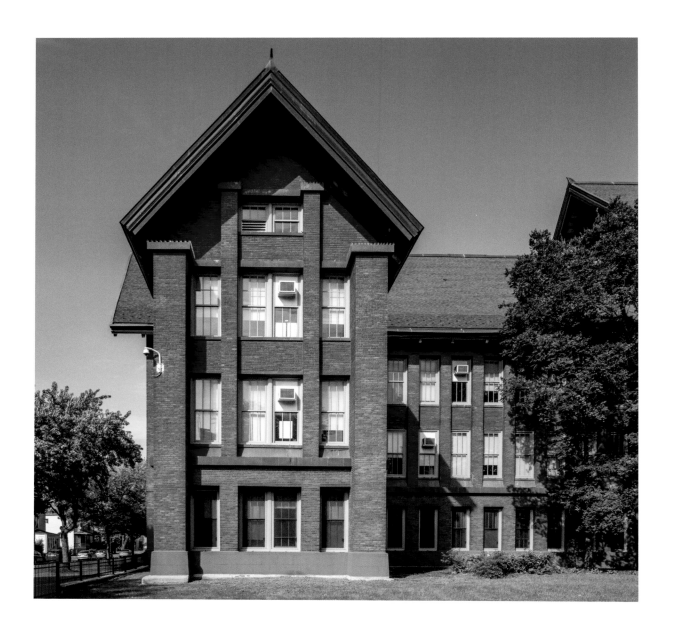

High School, at 3601 North Milwaukee Avenue, was built the same year as Bowen, and the two schools are virtually identical twins, both having been designed by Perkins. Schurz has been a city landmark since 1978 and made the National Register of Historic Places in 2011 as an acclaimed masterpiece of Prairie School architecture.

Bowen, which sits in the predominantly black and Latino neighborhood of South Chicago, was never given landmark status nor a National Register listing. The 1978 city report that sucessfully made the case for granting landmark status to Schurz doesn't even *mention* Bowen, although it lists Perkins's other works.[2]

There is a similar oversight on the West Side, where the architecture of the 1909 Perkins-designed George Tilton School, 223 North Keeler Avenue, is hardly noticed by anyone outside of the building's students, teachers, and neighbors, while its North Side twin, the former Lyman Trumbull School, 5200 North Ashland Avenue, gained city landmark status in 2019 and will be converted to a private elementary school.

Anthony Overton Elementary School, 221 East Forty-Ninth Street, was closed in 2013, but the building might be able to teach a few lessons yet. Built in 1963, the three-story school designed by Perkins & Will is a superb example of midcentury modern architecture. The building is essentially a trio of glass and glazed-brick towers that are linked by glassy hallways on each floor. The result is a wonderfully transparent and open building, filled with views and natural light and—when the school was in business—animated by the movement of its young students.

James H. Bowen High School, 2710 East Eighty-Ninth Street
A classroom wing showcases the building's symmetry, boldness, and beauty.

Bronzeville real estate developer Ghian Foreman purchased the school after it closed and worked to get it listed on the National Register of Historic Places. He's allowed artists and designers to access the building and keep it busy and populated with public events while he works to figure out the schoolhouse's next chapter.

Anthony Overton School, 221 East Forty-Ninth Street

Opposite: Glass-paned, gallery-like hallways surmount the school's south entry.

Right: Interior view from a hallway.

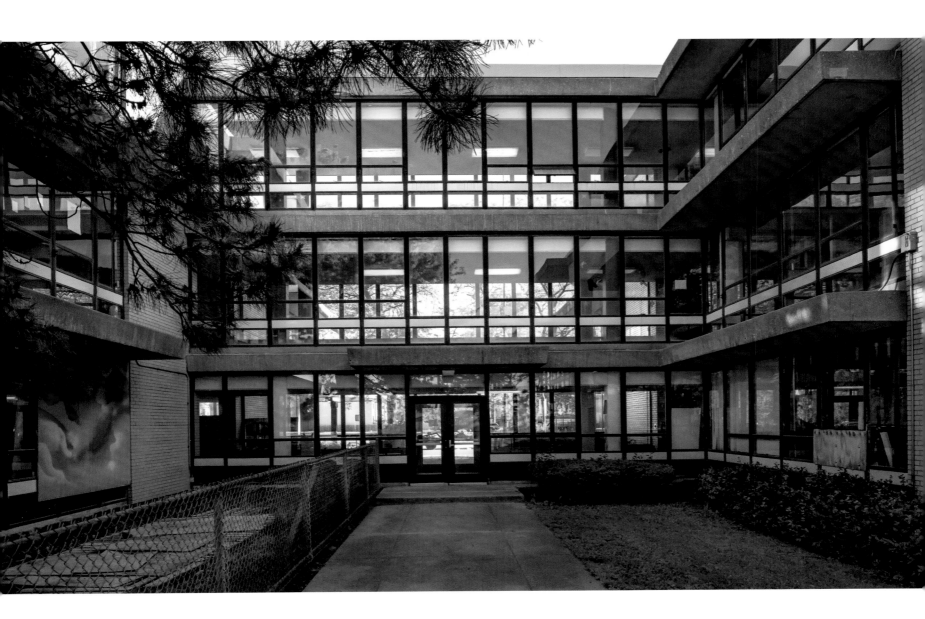

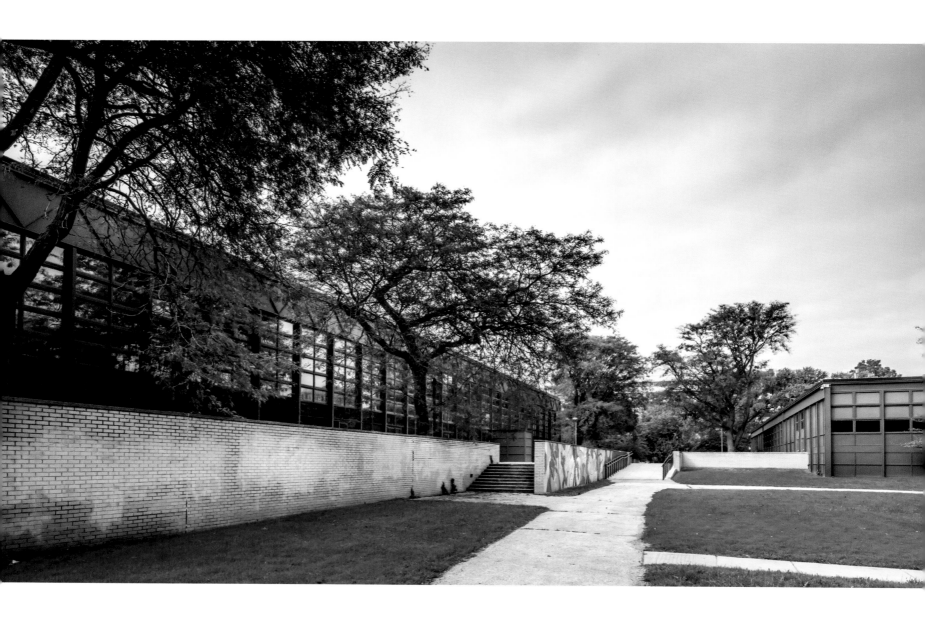

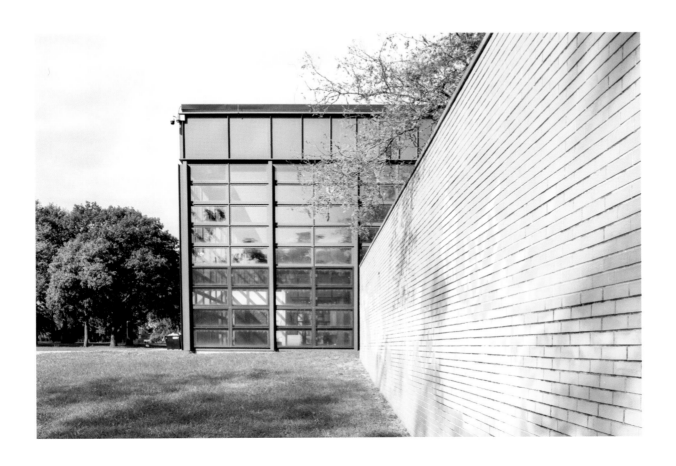

Walter H. Dyett High School for the Arts, 555 East Fifty-First Street

Opened in 1972, this public school, comprising a classroom wing and a separate natatorium, was designed by David Haid and African American architect Kenneth Childers.

Above: A view of the natatorium.

Another modernist educational complex, Walter H. Dyett High School for the Arts in the South Side's Washington Park neighborhood, shows how good design can redeem a bad situation. School and city officials blundered in 1972 by building the school on the grounds of the historic Frederick Law Olmsted–designed Washington Park, just off Fifty-First Street. But architects David Haid, another Mies protege, and Kenneth Childers, an African American, mitigated this mistake by designing a dark, glassy, two-building steel-and-glass complex—a natatorium and a main building with classrooms—sensitively scaled and sited to be at one with the park, rather than overwhelming it.

If only the Obama Presidential Center now taking shape in the South Side's Jackson Park could be as subtle. But more on that later.

Dyett might well be locked away or otherwise lost today were it not for residents and activists who fought to keep the school open. Dyett supporters had to stage a thirty-four-day hunger strike in 2015 to save the school. Their voices—and votes—alone weren't enough; they had to risk their lives. If that isn't indicative of how the people of the South and West Sides are treated by their own government, I don't know what is.

In Hyde Park, on the southeast edge of the University of Chicago campus, the D'Angelo Law Library enjoys relatively meager architectural notoriety, given that it was designed by Eero Saarinen, one of the most celebrated architects of the twentieth century.[3]

D'Angelo Law Library, University of Chicago, 1120 East Sixtieth Street
Located on the southeastern edge of the University of Chicago campus, this building was designed by Eero Saarinen and completed in 1959.

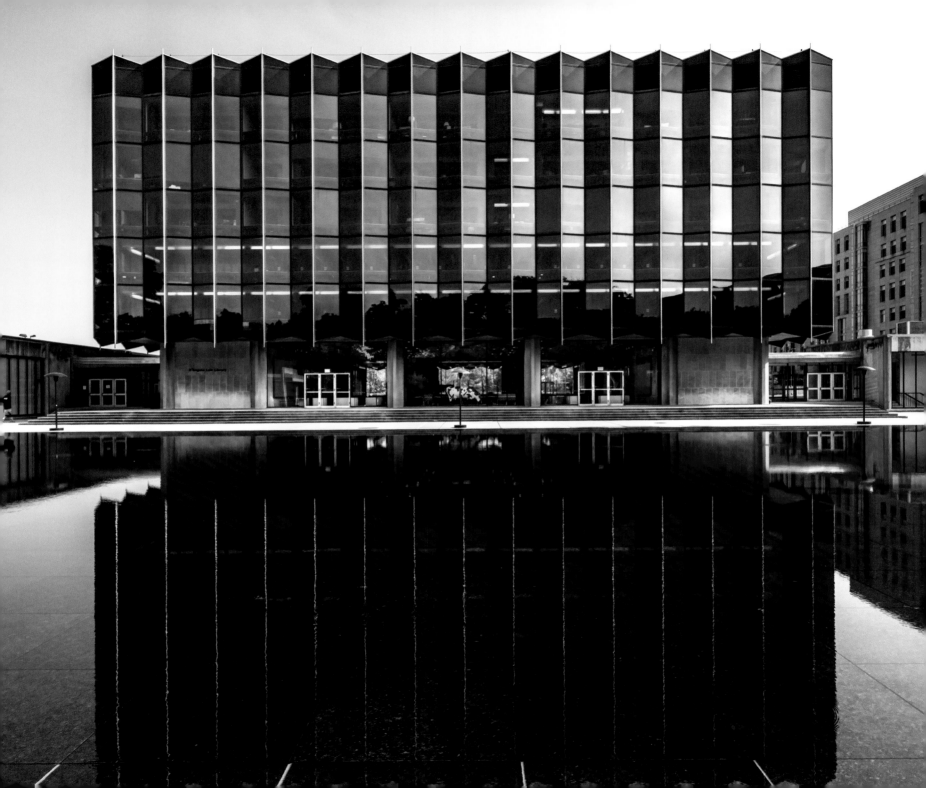

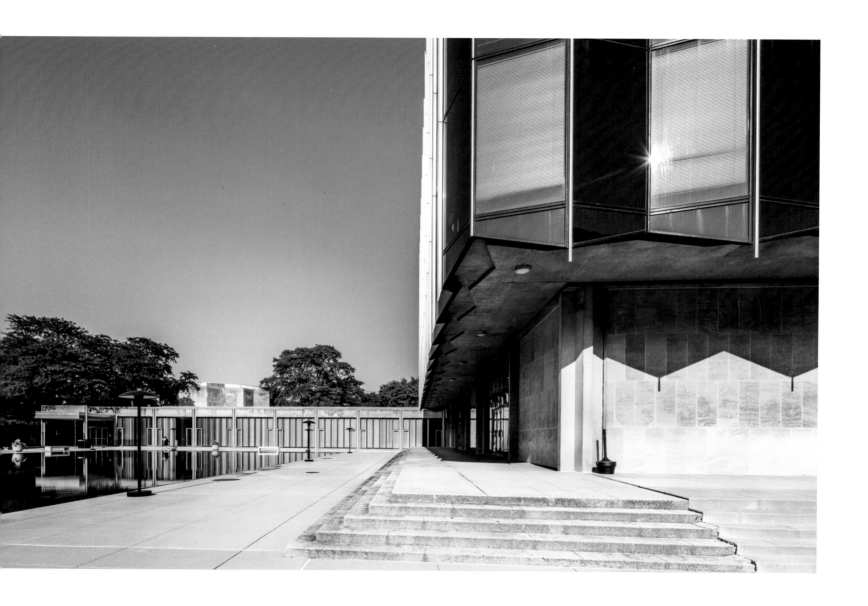

Built in 1959, just three years before the architect's curvy, glassy, Jet Age–sexy TWA Flight Center at New York's Kennedy Airport, the library is a showstopper, with its crisp, undulating curtain wall of bluish glass that reads like the folds of an accordion's bellows as it rises above a solid, Bedford limestone base. U.S. Supreme Court Justice Earl Warren was there when the building's cornerstone was laid. Then Vice President Richard M. Nixon attended the building's dedication.[4] And Barack Obama, an adopted son of the South Side and future president, taught constitutional law there from 1992 to 2004.

D'Angelo Law Library is not in any danger. The university even restored the complex in the early 2000s. Still, the noteworthy building by an internationally known architect isn't a protected city landmark, nor is it listed on the National Register. And one can't help but notice this: a superlative 2016 PBS American Masters documentary *Eero Saarinen: The Architect Who Saw the Future* heavily featured the architect's collegiate designs, yet somehow managed to miss the law library entirely.

Another building on the University of Chicago campus that deserves more attention is its South Campus Chiller Plant, designed by Helmut Jahn and completed in 2009. Tucked away near Sixty-First Street and the elevated Metra commuter rail tracks, the silvery power plant is architectural steampunk, looking as if it could be the work of some nineteenth-century futurist. During the day, clouds and sky are reflected in its expansive glass facade, but at night interior lights come up to reveal the plant's inner workings.

D'Angelo Law Library, University of Chicago, 1120 East Sixtieth Street
Here the glass tower meets its limestone base. Eero Saarinen's clean lines and geometry are also on display.

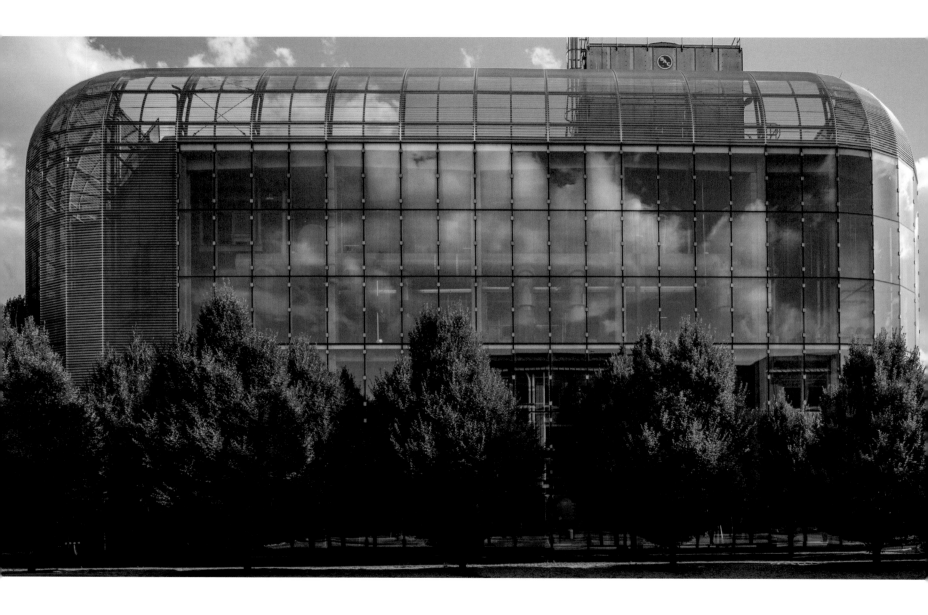

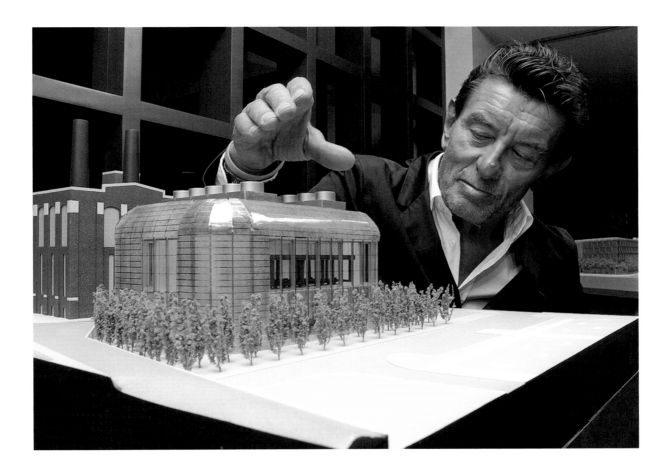

South Campus Chiller Plant, University of Chicago, 6053 South Woodlawn Avenue
This glass and metal power plant designed by Helmut Jahn was completed in 2009.

Helmut Jahn
The architect of the University of Chicago South Campus Chiller Plant poses with a model of the building in 2010.

Eight miles due west of Hyde Park, two of the most architecturally dynamic school buildings in the city sit side-by-side at Fifty-First Street and Homan Avenue, in the Gage Park community, a working-class Latino neighborhood.

No doubt the architecture of these two newer and absolutely futuristic-looking schools would be widely celebrated—at least noticed—if they were located on the city's North Side, or even portions of the South Side that are close to the lake and are seen as "desirable" to outsiders. But on West Fifty-First Street, across the street from Los Amigos Restaurant—and they deliver, by the way—Jovita Idár Elementary School and the Victoria Soto High School are relatively unknown to most Chicagoans.

The silvery, ground-hugging Jovita Idár Elementary School is all glass and curves, the lovechild of a sleek jetliner and the architectural futurism of Oscar Niemeyer's Brasilia. Designed by Chicago architect Juan Moreno and Ghafari Associates, the charter school was built in 2011 and was originally UNO Soccer Academy before its name change. The building encircles an enclosed outdoor space where students can gather, sit, or play on a small-scale soccer field—there is also a larger, competitive-sized field on the campus.

Soto High School, designed by Wight & Co., opened in 2013, and reads like a glass circle. Within the circle there is a substantial courtyard, designed with a naturalist bend, with garden-like spaces.

Together the two schools give a jolt of good design to one of the corners of Chicago that needs it most. The campus also redeems what had been a vacant industrial site.

"Most schools in predominantly Latino areas of Chicago have been designed as fortresses to fortify their students against their surroundings," Moreno said. "This building [Ivár] does just the opposite."[5]

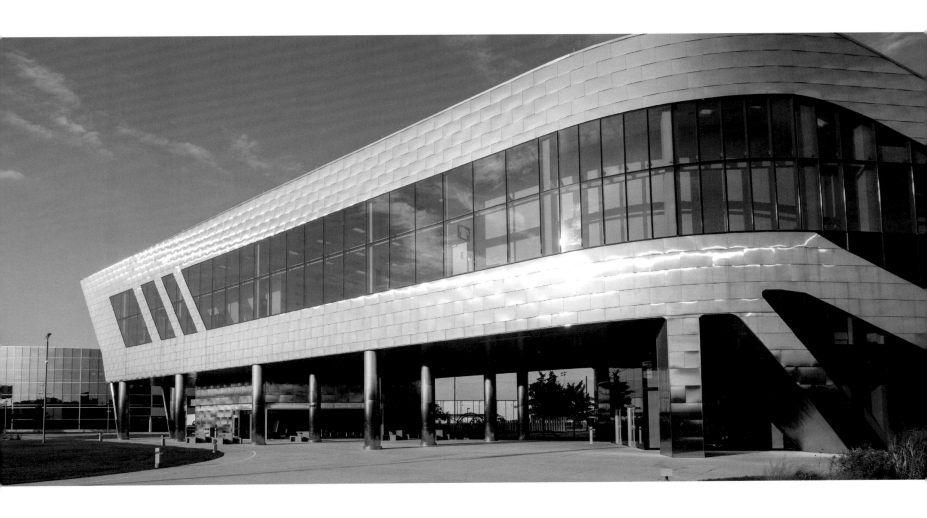

Jovita Idár Elementary School, 5050 South Homan Avenue

Built in 2011 and named in honor of a Mexican American journalist and activist, this sleek charter school was designed by Juan Moreno and Ghafari Associates.

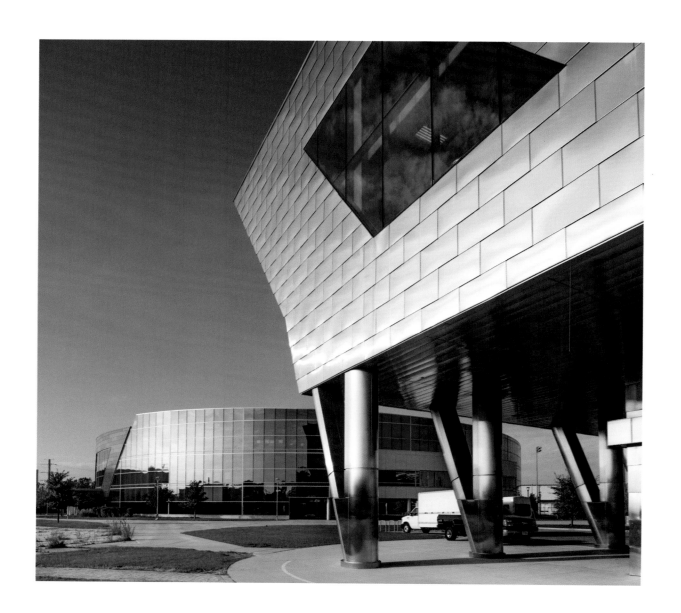

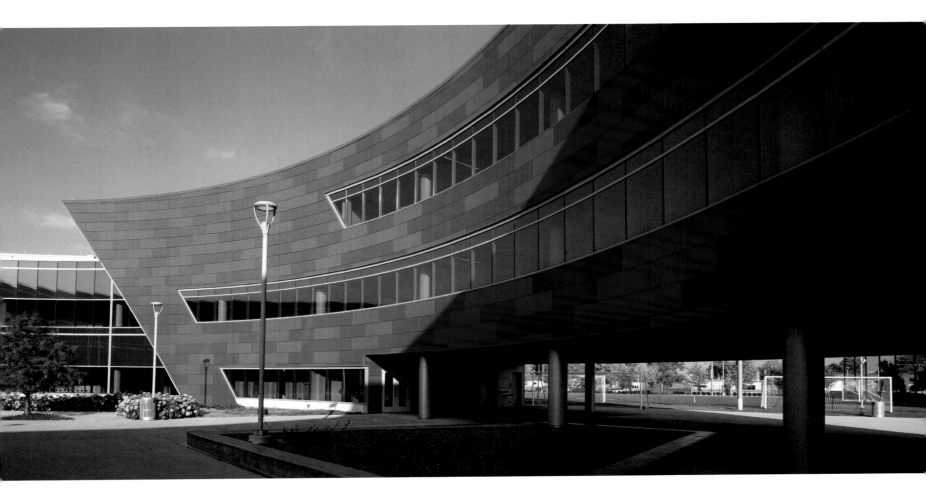

Jovita Idár Elementary School, 5050 South Homan Avenue

Opposite: The elementary school (right) shares its campus with glassy, circular Victoria Soto High School.

Victoria Soto High School, 5025 South St. Louis Avenue

Above: Designed by Wight & Co. and built in 2013, Victoria Soto High School is named after a twenty-year-old schoolteacher who was killed protecting her students in the 2012 Sandy Hook Elementary School massacre.

The same thing could be said of the Gary Comer Youth Center, a burst of color and form at Seventy-Second Street and Ingleside Avenue, in the Greater Grand Crossing neighborhood. For years, community centers tended to look like bunkers in tough neighborhoods like these—hunkered down, closed-off buildings designed for safety and function, but little else. Not here. Built in 2006 and designed by architect John Ronan, the building is clad in bright red-, white-, and gray-fiber cement panels, and just lights up the intersection where it sits. You hardly notice there are minimal amounts of glass— and even that's bulletproof, as requested by the community, ever mindful of the realities of the area. Still, the center shows how safety issues can be addressed with good design. The center was funded by the late Gary Comer, the founder and CEO of retailer Lands' End, who grew up in the community in the 1930s and 1940s.

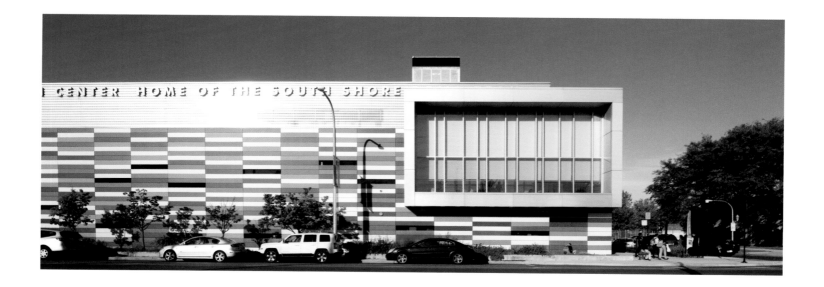

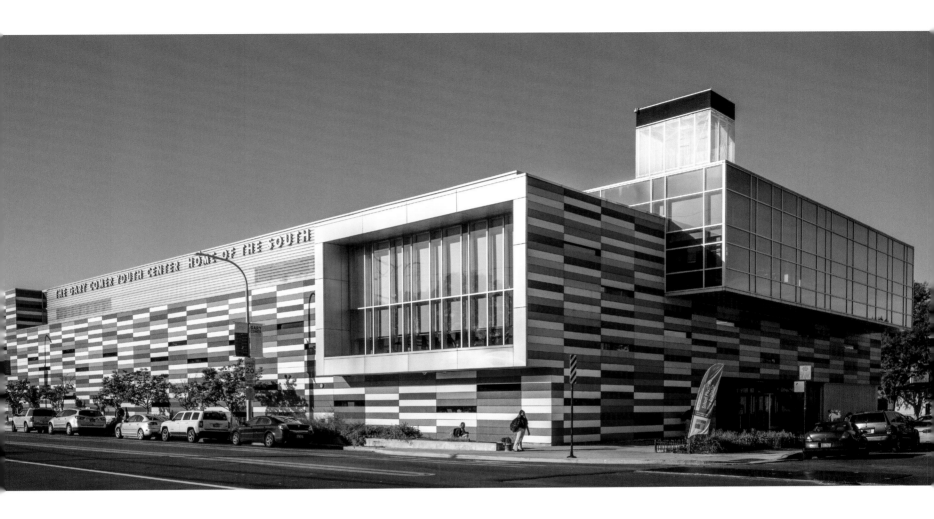

Gary Comer Youth Center, 7200 South Ingleside Avenue

Above: Built in 2006 and designed by Chicago architect John Ronan, this brightly colored community center lights up a section of its working-class neighborhood.

Opposite: This view shows the building's eye-catching side elevation, facing South Chicago Avenue.

Then there is Stony Island Church of Christ, built in 1959. Located at Eighty-Fourth Street and Stony Island Avenue, the church has yet to be listed on any architectural survey, which is a shame. The modernist edifice is a very fine little building by Chicago architect Ray Stuermer, who was once chief of design for Raymond Loewy,[6] the celebrated twentieth-century industrial designer whose work ranged from the iconic Lucky Strike cigarette packaging to the zoomy and va-va-va-voomy Studebaker Avanti sports coupe. The small church, built for a congregation of two hundred, was produced on a modest $125,000 budget.[7] In today's dollars, that would be just over $1 million. But with that tight budget, Stony Island Church is a standout: a sleek, impressive, and reverent work with an angled granite facade that is divided by a slender, two-story glass entrance.

Chicago has a fine collection of churches in general, but the South Side is particularly, shall we say, *blessed*, in both design quality and sheer numbers.

"I grew up in Back of the Yards and we had twelve churches in two square miles," Pacyga said. "If you drew a larger circle, it was around thirty-five or thirty-six Catholic churches. And if you add on [neighboring] Bronzeville, then you've got the [African Methodist Episcopal] and other churches."[8]

Stony Island Church of Christ, 1600 East Eighty-Fourth Street

This small, modernist church is located next to bustling Stony Island Avenue; it was designed by Ray Stuermer, an architect who was once chief of design for industrial designer Raymond Loewy.

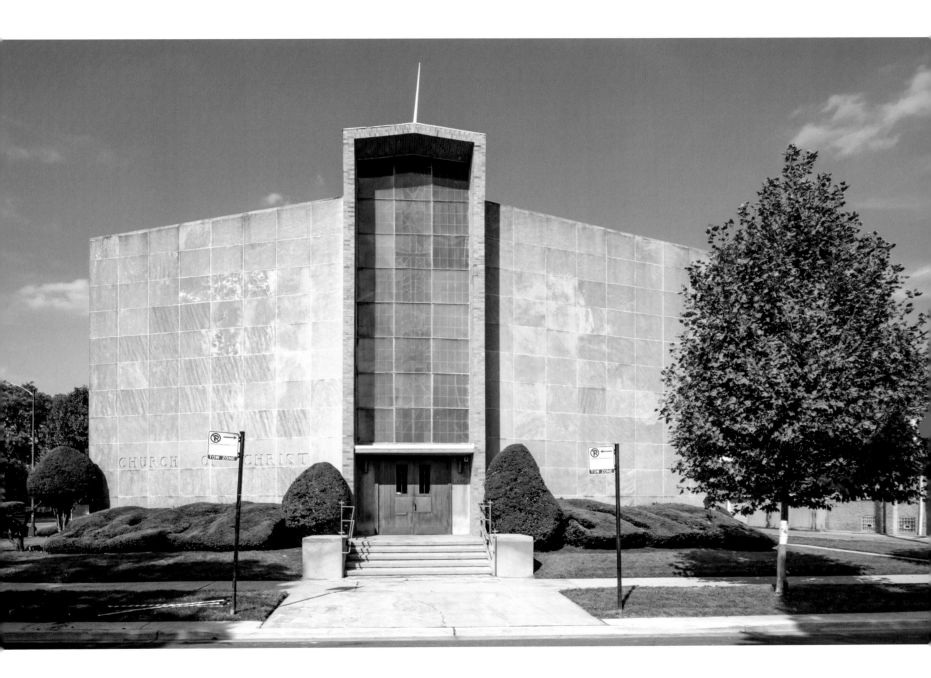

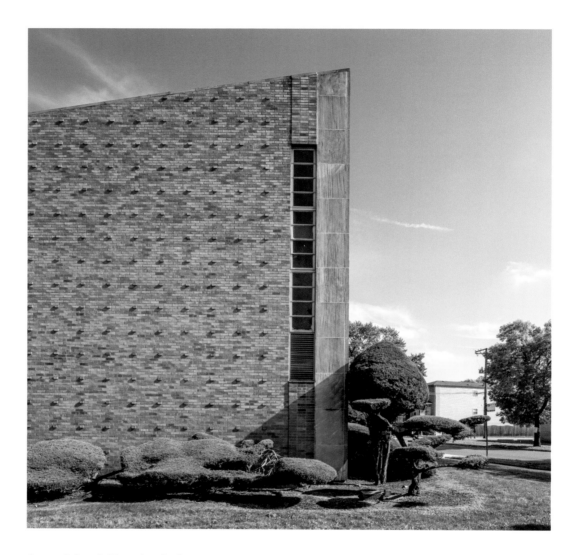

Stony Island Church of Christ, 1600 East Eighty-Fourth Street

A side view of the church reveals a raised-brick pattern and a ribbon of windows designed to let western light into the building.

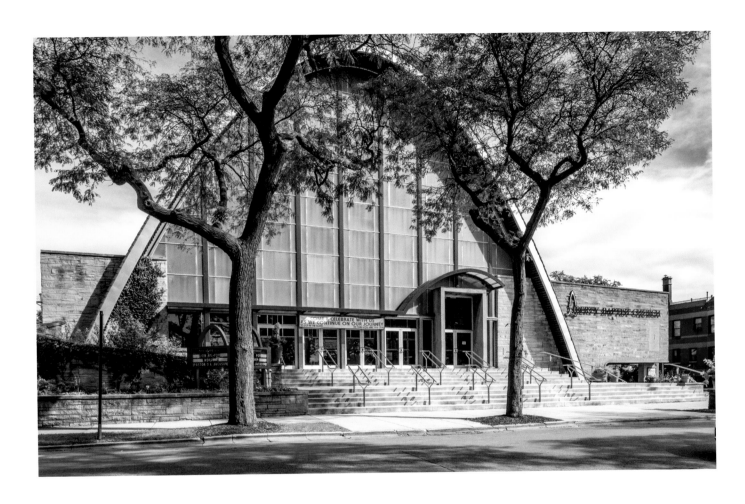

Liberty Baptist Church, 4849 South King Drive

Designed by architect William Alderman and completed in 1956, the church provides a dash of postwar modernism on an otherwise predominately early-twentieth-century boulevard. The arched parabolic roof is made of laminated wood arches and is covered in red tile.

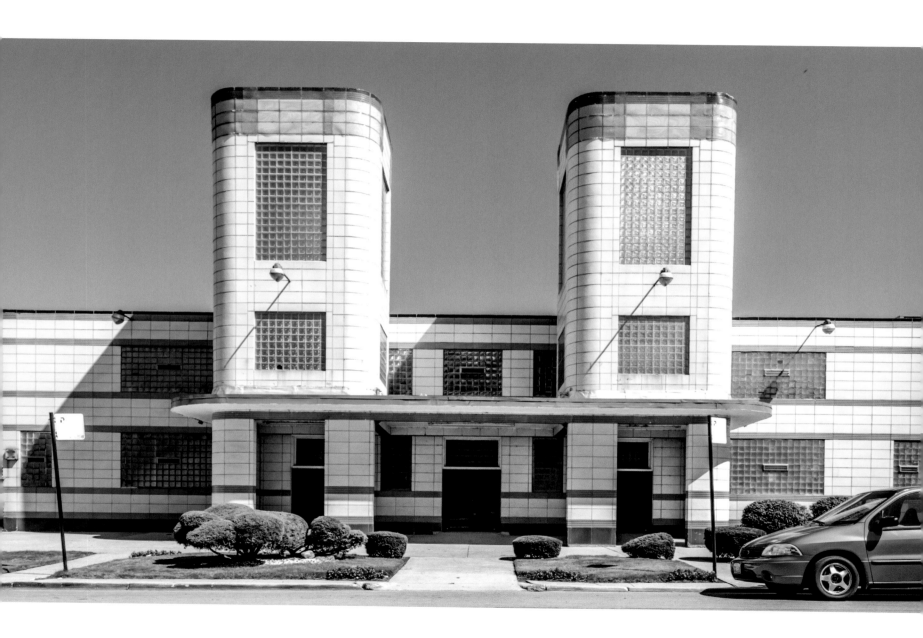

That's because from the late 1800s through the 1940s, new South Siders arriving from all over Europe and the Jim Crow South tossed enough money into collection plates (or bought High Holiday tickets) to assure that every neighborhood—no matter how poor or rich—had the best-looking churches and synagogues in the city.

Bronzeville residents often took over existing churches when whites left the neighborhood. But when the congregations built their own churches, the results could be knockouts, architecturally.

Walter Thomas Bailey teamed with black structural engineer Charles Sumner Duke and converted an old hat factory into the streamlined and modernist First Church of Deliverance at Forty-Third Street and Wabash Avenue in 1939.[9] The conversion added a second story and doubled its width. The building was reclad in cream-colored terra-cotta panels. Bands of terra-cotta run across the face of the building, accenting the structure's horizontality. The art moderne rounded towers flanking the church's entry were added in 1946 by the predominantly white architecture firm Kocher Buss & DeKlerk. The church's pastor, the Rev. Clarence Cobbs, nicknamed the towers "Old Testament" and "New Testament."[10]

First Church of Deliverance, 4315 South Wabash Avenue
The prominent twin towers on the exterior of the church were originally nicknamed "Old Testament" and "New Testament."

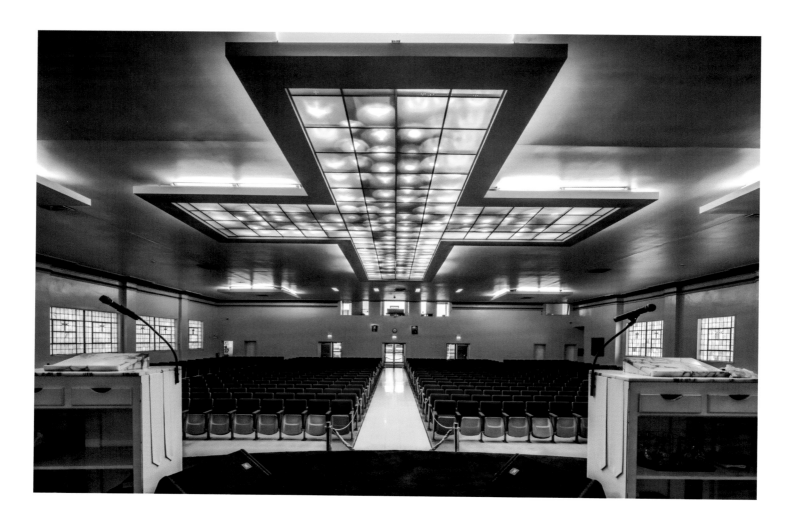

First Church of Deliverance, 4315 South Wabash Avenue

This interior view shows the lighted cross above the main aisle.

Opposite: The choir loft, featuring Art Deco railing.

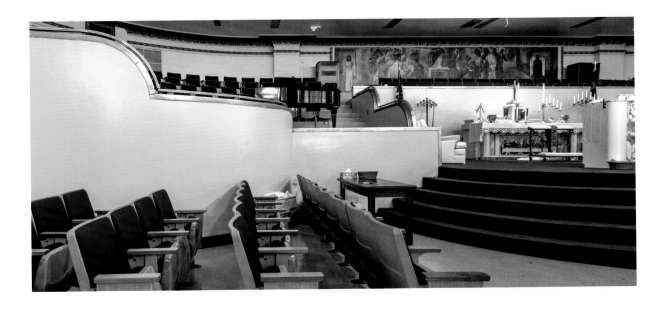

One among many churches built in Pacyga's old neighborhood is St. Gabriel, constructed at Forty-Fifth Street and Lowe Avenue, near the Stock Yards, in 1888. "The history of American church architecture includes few structures that are finer or less well-known than Burnham and Root's St. Gabriel's Catholic Church . . ." Thomas S. Hines said in his book *Burnham of Chicago: Architect & Planner*.

St. Gabriel's architect, John Wellborn Root, tossed aside the usual neo-Gothic and Victorian frou-frou of the day, giving the congregation a bold-looking brick building with deep rooflines and a 160-foot corner tower. Built for Irish immigrant workers, St. Gabriel has a simplified Romanesque design that emphasizes the edifice's form and geometry rather than its adornment, giving the nineteenth-century church a hint of modernity that is still evident today. Root is said to have based the design on that of a medieval Romanesque church in Toulouse, France.[11]

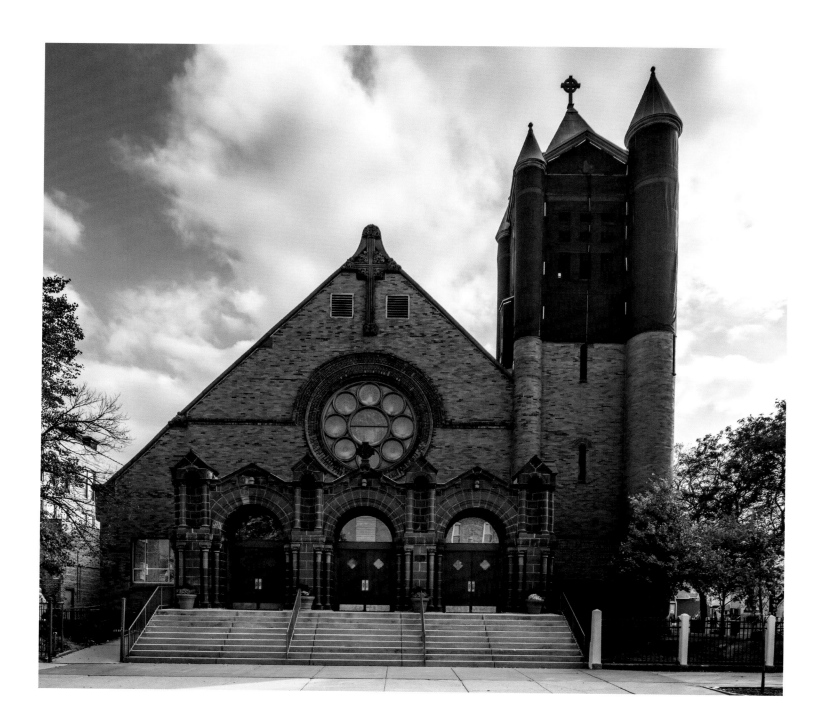

St. Gabriel Catholic Church, 600 West Forty-Fifth Street

Opposite: The church's handsome main elevation and tower.

Above: An intricately detailed section of the building's main entry.

If a medieval church in Toulouse inspired the design of St. Gabriel, it's hard to tell which one, but I'd lay odds it was the Basilica at St. Sernin. There is a faint resemblance between the buildings. And St. Sernin is Toulouse's most noteworthy religious edifice because it is the largest basilica in Europe.[12]

It's also good to see the thriving Chinatown neighborhood gain a much-needed new library in 2015, let alone one that is a clear break from the Americanized—and thus stereotypical—"Chinese" design styles. Brian Lee of SOM designed the elliptically shaped two-story glass building at Twenty-First Street and Wentworth Avenue.[13] The facade is surrounded by thin vertical metal fins that act as sunshades, designed to keep excessive amounts of heat and sunlight from reaching the building's open, colorful, and light-filled interior. The best time to see the building is at dusk or at night, when it lights up the community like the beacon it has become.

5 To Live and Buy on the South Side: Residential and Commercial Architecture

Few Chicago neighborhoods can rival the South Shore neighborhood's architecture. The community seemingly rises out of the lake, with an impressive wall of residential high rises built between the 1920s and the 1970s. As you go inland, the scale shrinks a little, giving way to block after block of substantial brick apartment and condominium buildings, with exteriors laced with limestone or terra-cotta detailing.

A few more blocks west, single family homes take over, designed in a variety of 1920s middle-suburban architectural styles. Among the standouts is the Allan Miller House, 7121 South Paxton Avenue, a 1913 Prairie School beauty designed by architect John Van Bergen.

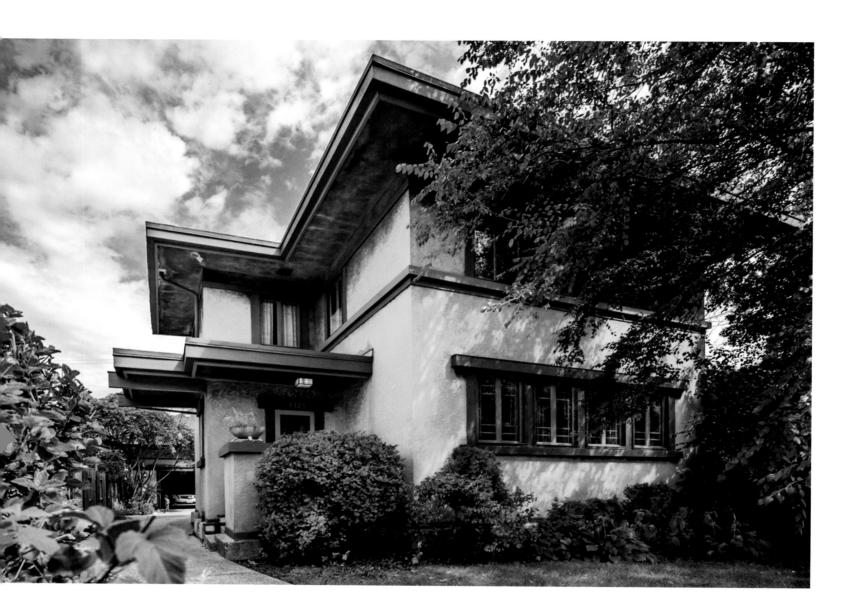

The private residence is a city landmark that is also listed on the National Register of Historic Places, and it's not hard to see why. The blocky, right-angled stucco house is strikingly modern for a home built just five years after the Ford Model T was introduced. The interior is awash in leaded glass; woodwork and built-ins are made of birch, a wood known for its beautiful straight grain. There are cubist light fixtures and a commanding Roman-brick living-room fireplace.

Van Bergen, who had been an architect in Frank Lloyd Wright's studio, based the design on Wright's "Fireproof Home for $5,000" plan that was first published in *Ladies Home Journal* in 1907 and featured in the architect's famed Wasmuth Portfolio in 1910. But Van Bergen's version is larger, with a porch on the home's southern side and a two-story addition in the rear. Seen in its context, surrounded by handsome but architecturally traditional homes along Paxton Avenue, the Miller House's importance, elegance, and modernity become even more apparent.

Shaan and Joanna Trotter bought the Miller House in 2015.

"We have always loved South Shore," said Joanna Trotter, an urban planner. "There is the architecture, not only of the house itself, but of the neighborhood, it's stunning."[1]

Allan Miller House, 7121 South Paxton Avenue

Architect John Van Bergen based this two-story stucco design on Frank Lloyd Wright's plan for affordable fireproof houses. It was built in 1915.

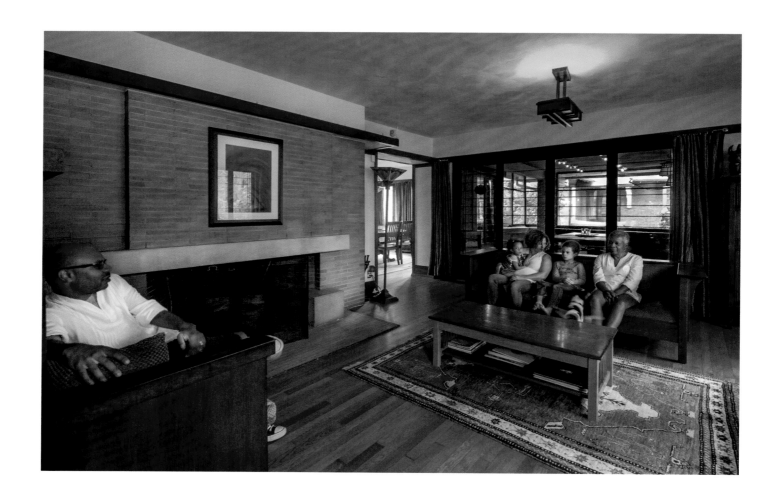

Allan Miller House, 7121 South Paxton Avenue

The Trotter family relaxes in the living room of their home.

South Shore is a well-planned community with the same architectural and physical characteristics of the Chicago suburbs of Oak Park and Evanston. The neighborhood's main drag, Seventy-First Street, struggles, however. Once a retail showplace that included shops, restaurants, and movie theaters, the thoroughfare has been saddled with vacancies and dominated by a mix of low-grade commercial business—dollar stores, beauty supply houses, and fast food places—since the 1980s.

"We don't have point people at City Hall," Trotter said of South Shore. "We still don't have a comprehensive plan for South Shore. There are property owners getting tax breaks for keeping their property vacant. So we struggle with that."

Another South Side residential treasure is the Dr. E. J. Ingram House at Sixty-Fifth Street and Eberhart Avenue in the Woodlawn community; it was designed by Roger Margerum, a black architect who studied under Mies.[2]

Built in 1959, the horizontal one-story brick, steel, and glass modernist home visually disrupts the block's virtually unbroken line of architecturally worthy, but rather traditional, two- and three-story 1920s brick or limestone buildings. The front of the Ingram House is a glass curtain wall that smiles broadly onto Eberhart. The house was virtually unknown to most Chicagoans, and absent from anything written about Chicago architecture, until it made the news when it popped on the market in 2017 at the bargain-basement price of $150,000.

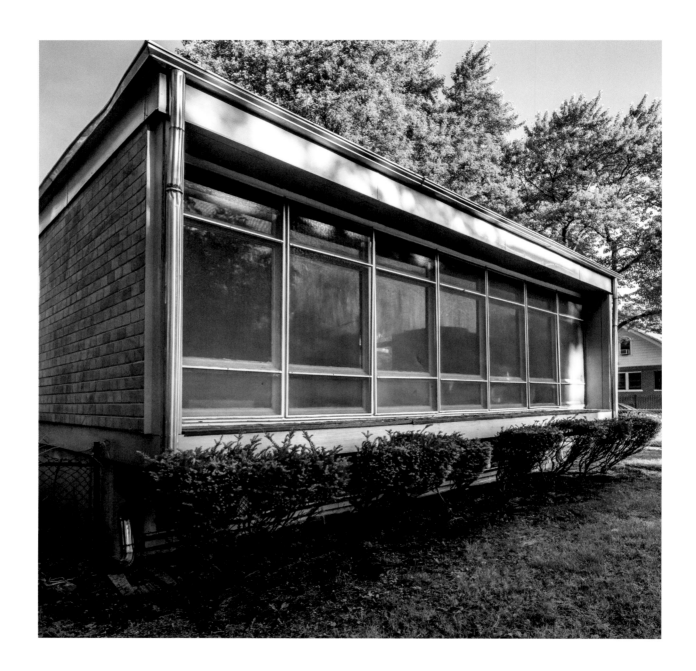

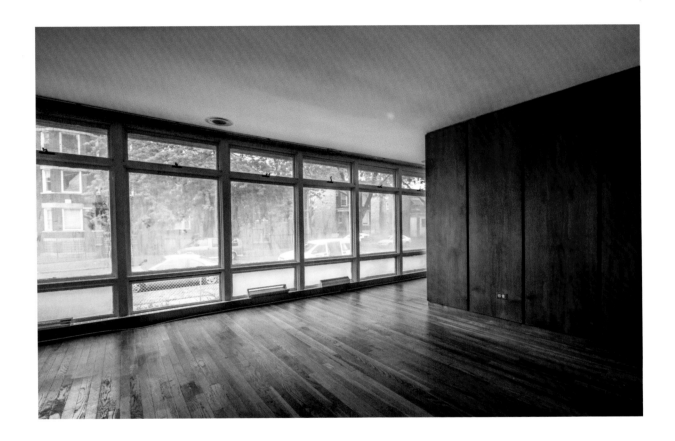

Dr. E. J. Ingram House, 6500 South Eberhart Avenue

Designed by African American architect Roger Margerum, for black physician E. J. Ingram, this 1959 home stands out in a neighborhood of circa 1920 residences.

Above: A paneled room divider in the living room.

Pioneering black Chicago architect John Moutoussamy is best known for his former Johnson Publishing Building, an eleven-story structure—and designated city landmark—at 820 South Michigan Avenue that overlooks Grant Park with a certain button-down coolness. Lesser known is the refined modernist home Moutoussamy designed for himself, his wife, and three children at 361 East Eighty-Ninth Place in the South Side's Chatham community. Built in 1954, the blonde-brick residence is elegant in its simplicity; the home and its integrated garage greet the street as a single rectangular piece.

The Moutoussamy House is part of a notable cluster of modernist houses that were built in Chatham as the neighborhood became a prime spot for solidly middle-class and well-off African Americans in the 1950s and 1960s.

Dr. E. J. Ingram House, 6500 South Eberhart Avenue
The rear of the home faces an equally modernist garage, also designed by Margerum.

John Moutoussamy House, 361 East Eighty-Ninth Place

Architect Moutoussamy designed this elegant one-story home for himself and his family.

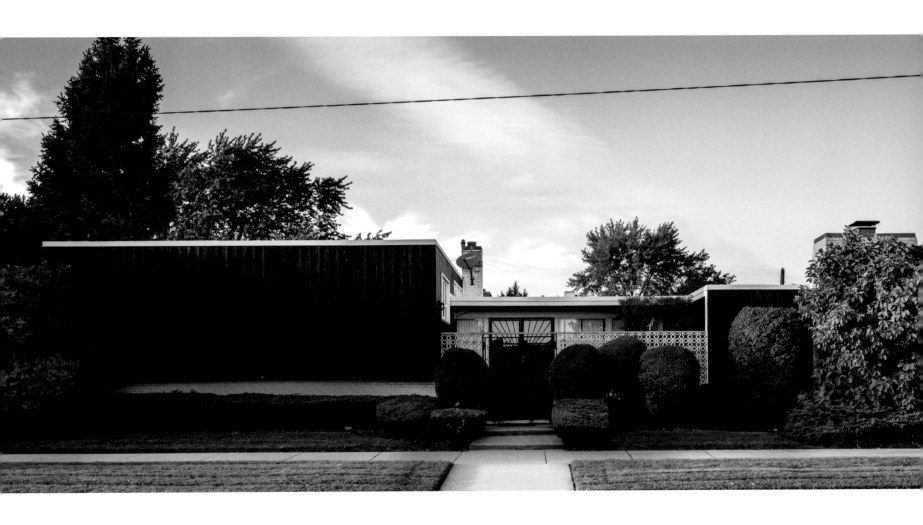

8459 South Michigan Avenue

Built in 1958, this Chatham home is an exercise in geometry—right down to its landscaping and topiary.

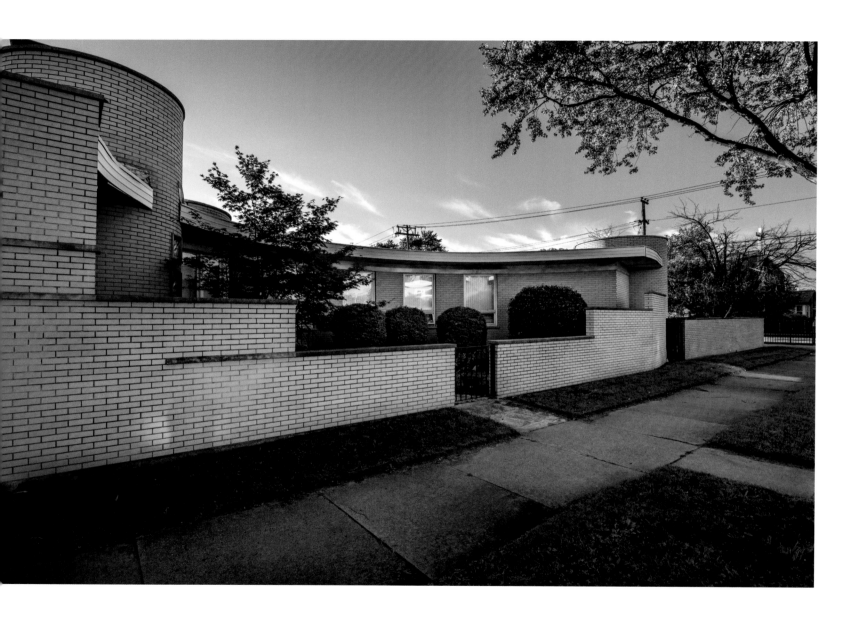

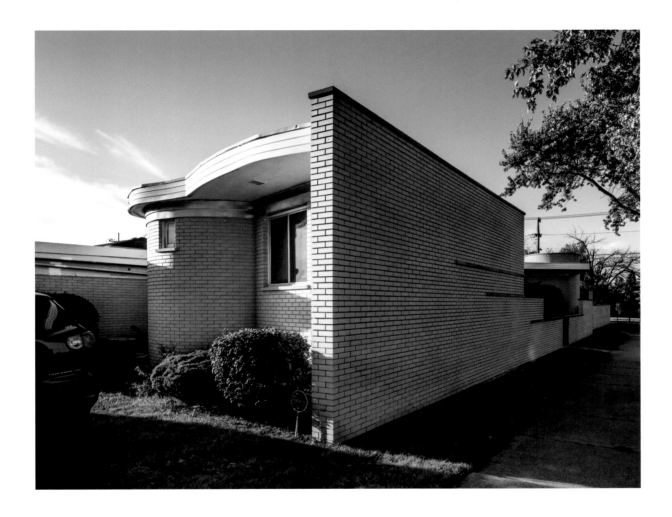

8650 South Michigan Avenue

Unusual angles and curves help this modernist home get the most out of its relatively small city lot. The C-shaped house has a neat entry garden behind a low brick wall that matches the house.

Above: The home's attached garage faces busy Eighty-Seventh Street. The garage provides direct car access from the street while shielding the living space from the thoroughfare's noise and bustle.

In Bronzeville, the D. Harry Hammer / Lu and Jorja Palmer House, 3656 South King Drive, is one of the finest remaining gaslight-and-cobblestone era mansions in the city. Sadly, it sits vacant and decaying. Built in 1885, this three-story mountain of red brick and brownstone was designed by William L. Clay for the prominent Hammer family. Black journalist and activist Lu Palmer and his wife Jorja owned the home in later years. Two organizations founded by the couple—Chicago Black United Communities and the Black Independent Political Organization—were headquartered in the home's coach house. The groups were instrumental in Harold Washington's successful 1983 and 1987 mayoral campaigns. The developer who now owns the home has allowed this treasure to fall into disrepair. And it is shameful.

D. Harry Hammer / Lu and Jorja Palmer House, 3656 South King Drive

Opposite: Designed by William L. Clay and built in 1885, this three-story dwelling is one of the city's best examples of the homes built for the very rich in nineteenth-century Chicago. The house is in deplorable condition, thanks to its Chicago developer owner.

Right: The boarded-up entrance of the vacant home.

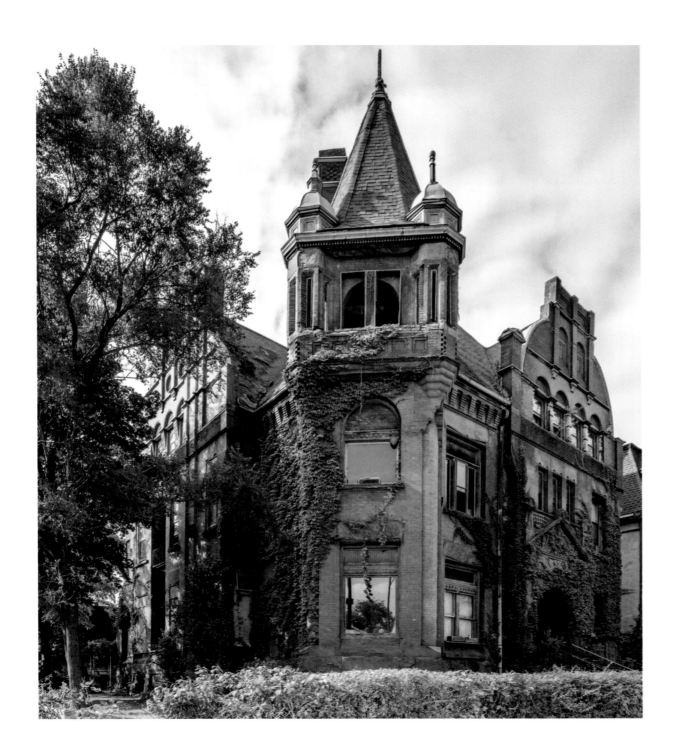

Saving troubled but architecturally significant buildings is an expensive exercise. But it is worth the cost, if the resurrection of Bronzeville's Rosenwald Apartments is any indication. The five-story art deco apartment house at Forty-Seventh Street and Michigan Avenue was close to death's door—vacant and derelict for more than fifteen years, and in a ward that was once represented by an alderman who called for the structure's demolition. The building was so bad that Bronzeville residents jokingly compared it to "The Carter," a reference to the decaying apartment building turned crack cocaine den in the 1991 movie *New Jack City*.

But there was a lot of fine architecture and black history behind the Rosenwald's walls. Built in 1929 by philanthropist and Sears & Roebuck president Julius Rosenwald as the Michigan Boulevard Garden Apartments, the building had an early life providing quality housing for black residents who were refused housing options outside of Bronzeville. Ernest Grunsfeld Jr., architect of Chicago's Adler Planetarium (and Rosenwald's nephew), designed the massive building, placing it on nearly a full city block and giving it a park-like interior courtyard. In its heyday, the building had 420 apartments and shops at its base along the Forty-Seventh Street retail strip. The building was a haven for middle-class African American residents, including boxer Joe Louis, writer Gwendolyn Brooks, and a young Quincy Jones.[3]

Rosenwald Apartments, Forty-Seventh Street and Michigan Avenue

Designed by architect Ernest Grunsfeld Jr. and built in 1929, the art deco apartment building occupies nearly a full city block and surrounds a park-like interior courtyard.

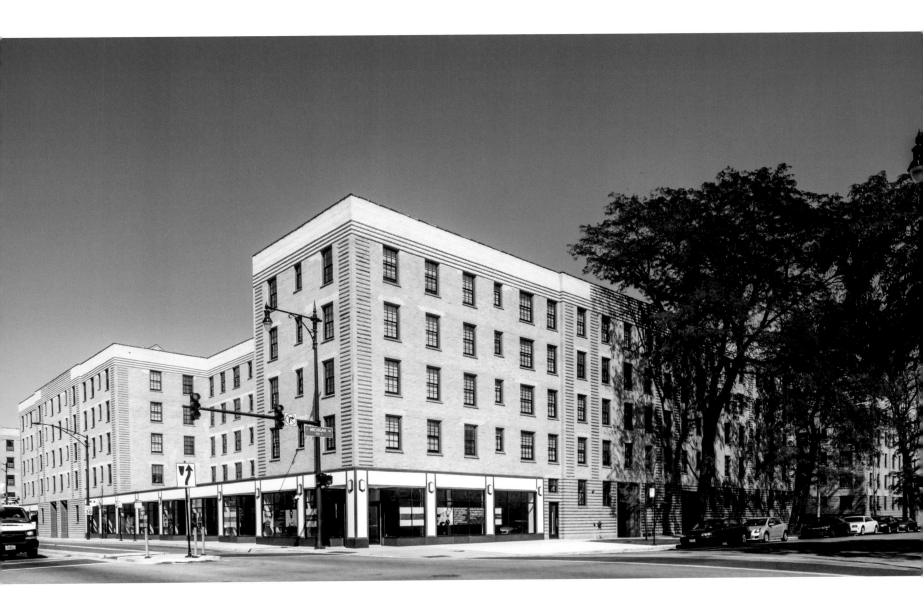

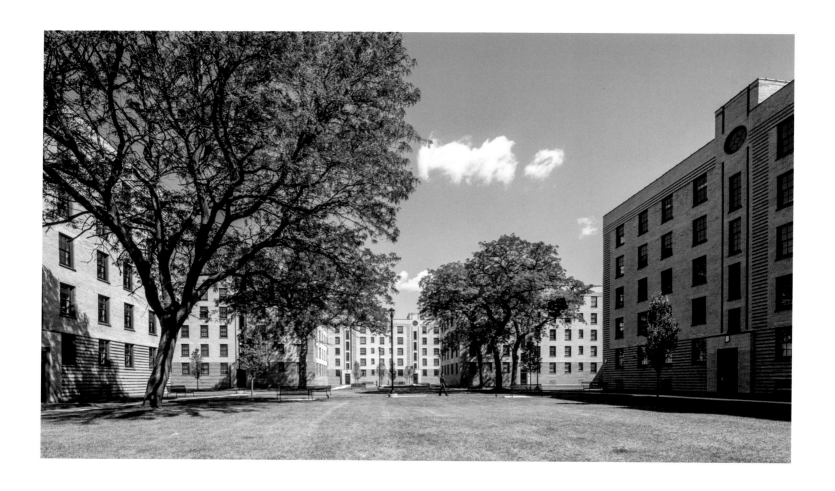

Rosenwald Apartments, Forty-Seventh Street and Michigan Avenue

Above: The Rosenwald's expansive interior courtyard.

Opposite: An up-close view of the Rosenwald's brickwork.

It took $132 million to pull the Rosenwald back from the brink: a massive capital stack composed of tax credits, credit, and equity funding. The rehabilitation brought back the building's original sun-kissed tan-brick exteriors and details. The unit count was lowered to 239 affordable one- and two-bedroom apartments, larger than the original ones. Elevators and air conditioning were also added. And that glorious courtyard was preserved and restored, providing valuable green space for Rosenwald residents. The effort earned the U.S. Department of Housing and Urban Development Secretary's Award for Excellence in Historic Preservation in October 2018. Saving the Rosenwald shows that even the most troubled buildings can become showplaces.

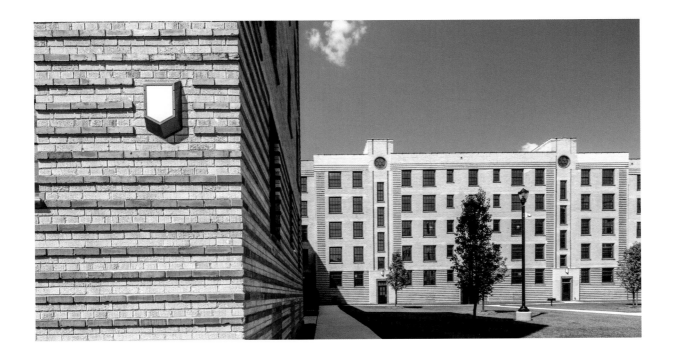

All it takes is the civic will to marshal the resources needed—and not to demolish the building before it can happen.

Like the Rosenwald, the Yale Apartments, at 6565 South Yale Avenue in the Englewood neighborhood, spent years in dereliction and abandonment and were nearly wrecked. What a loss, had the building been demolished. The Richardson Romanesque gaslight-era beauty designed by John T. Long looks like a work by architect Louis Sullivan, with its corners marked by a bold vertical line of bow windows and floral limestone detailing. Inside, seven stories of apartments face an enclosed light court topped by a skylight.

That's too much beauty to wind up as rubble in landfill. Thanks to a $9.5 million restoration and rehab in 2003, the building is a city landmark today, providing quality affordable housing for seniors—and one of the finest-looking surviving 1890s apartment houses in the city.

Yale Apartments, 6565 South Yale Avenue

This seven-story Richardson Romanesque 1890s apartment building by architect John T. Long now provides affordable housing for senior citizens.

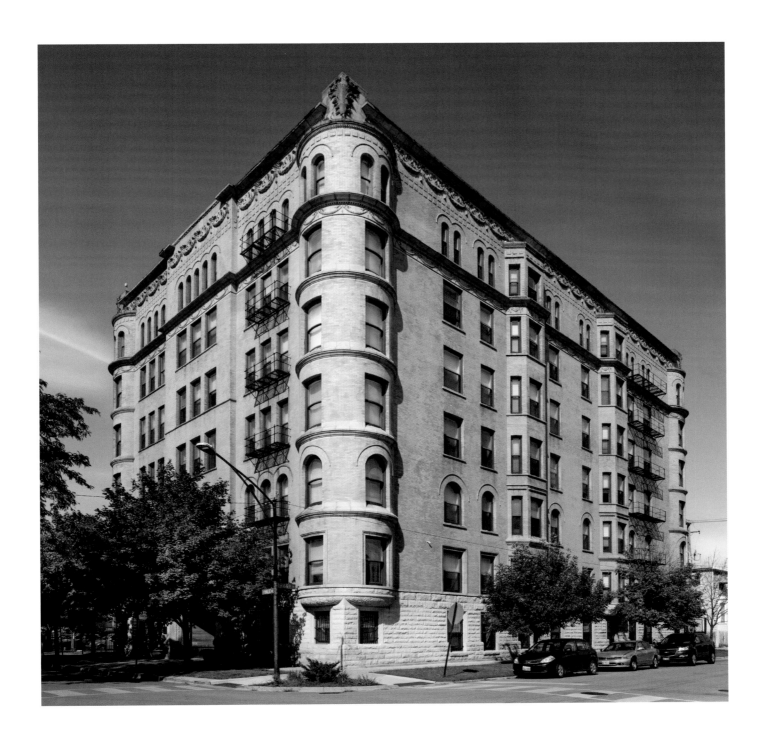

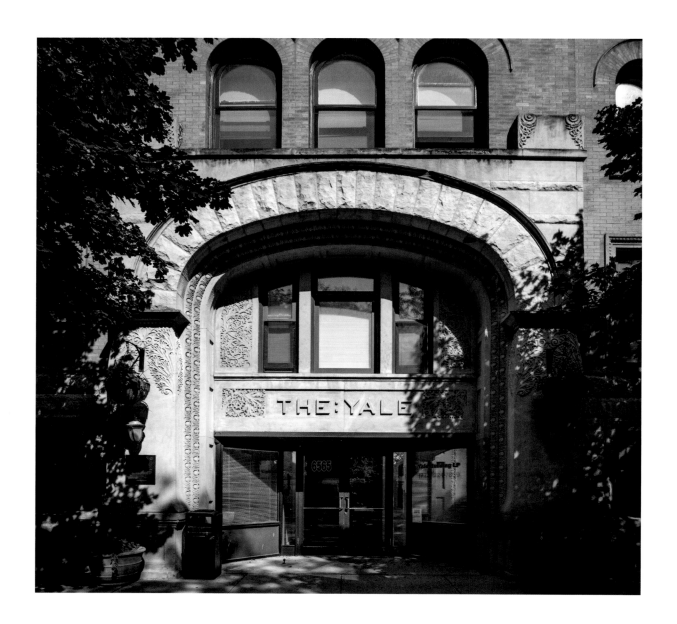

Yale Apartments, 6565 South Yale Avenue

Opposite: The main entrance displays the building's name in stone.

Left: A bay window features organic, Louis Sullivan–like detailing.

Another important South Side building is GN Bank, at 4619 South King Drive. The former Illinois Service Federal, built in 1962 and designed by the St. Louis–based Banker Builders Corporation of America, is a nearly perfectly maintained example of midcentury architecture, right down to the topiary in front of the building. The building is marked by triangular windows that peek out from a concrete facade that folds as crisply as the pleats of a banker's pants. But the bank's significance goes beyond its well-turned design. Black people created this bank, first as a savings and loan in a kitchen-turned-office at the Rosenwald during the Great Depression. And it remains black-owned, having been purchased in 2016 by the Nduom family of Ghana.

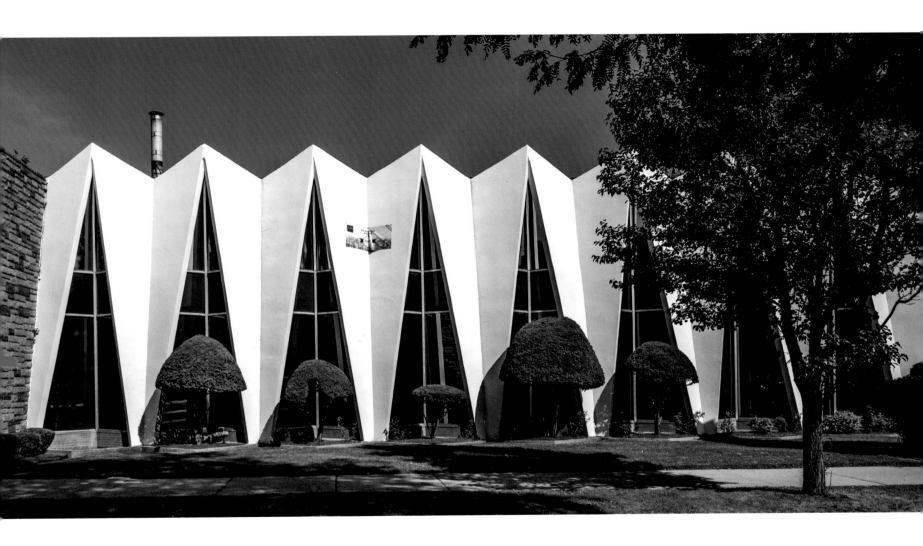

GN Bank, 4619 South King Drive

Built in 1962, this black-owned bank and modernist stand-out was designed by the St. Louis–based Bank Builders Corporation of America.

Opposite: The bank's stylish main entrance.

While we're talking about modernist neighborhood buildings, a personal favorite is Pride Cleaners, one of the most unusual buildings in Chicago. Built in 1959, on the northwest corner of Seventy-Ninth Street and St. Lawrence Avenue, the building rocks a spectacular, radically tilted, self-supporting hyperbolic paraboloid concrete roof that touches the ground on three sides, then shoots skyward above the main entrance.[4] An architectural creation from the Space Age, with a roof pointed toward the heavens—in all of Chicago's 238 square miles of architecture, there is absolutely no other building like this one.

The building still has its original freestanding sign, an exuberant pop art beauty with the letters of P-R-I-D-E each assigned their own primary-colored, lozenge-shaped backdrop. When the place was new, they'd flip a switch inside the cleaners and the lights would twinkle and flash with the exuberance of a Las Vegas marquee touting a Sinatra engagement at the Sands, rather than the humble name and services of a same-day dry cleaners.

The stretch of Seventy-Ninth Street in which the cleaners is located had been built-out for thirty years by the time Chicago modernist architect Gerald Siegwart sketched out his plans for Pride. The art moderne Rhodes Theater built about a block west in 1937 had been one of the street's few bows to modernity—the theater's opening-day ads trumpeted it as being "styled for tomorrow"[5]—but even art moderne wasn't hip by the late 1950s. When Pride arrived, the building was as radical as a flashy new 1959 Cadillac—tail fins and all—roaring past a row of Model Ts.

Pride Cleaners, 558 East Seventy-Ninth Street

Designed by architect Gerald Siegwart and built in 1959, the building has an eye-catching hyperbolic paraboloid concrete roof.

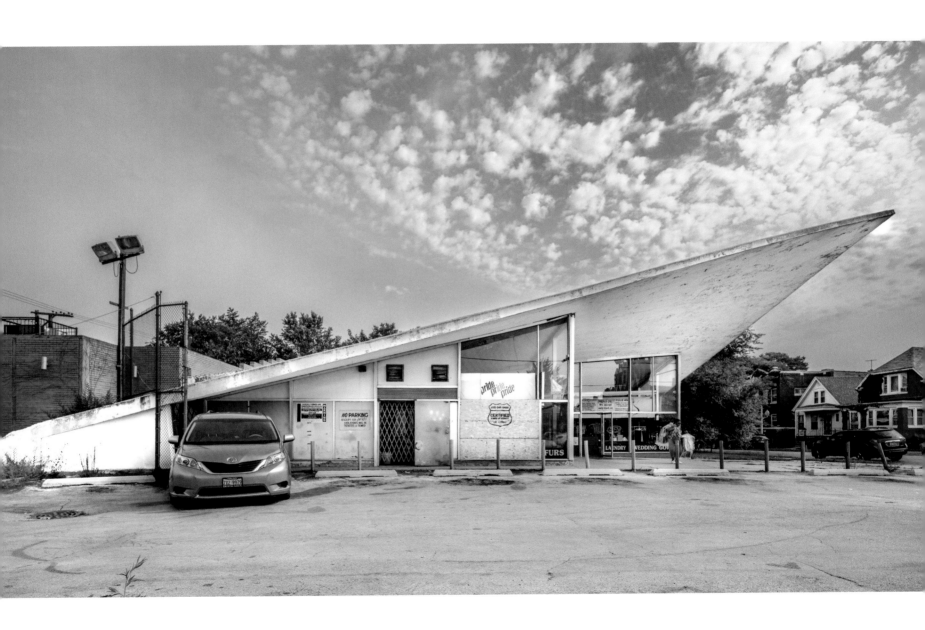

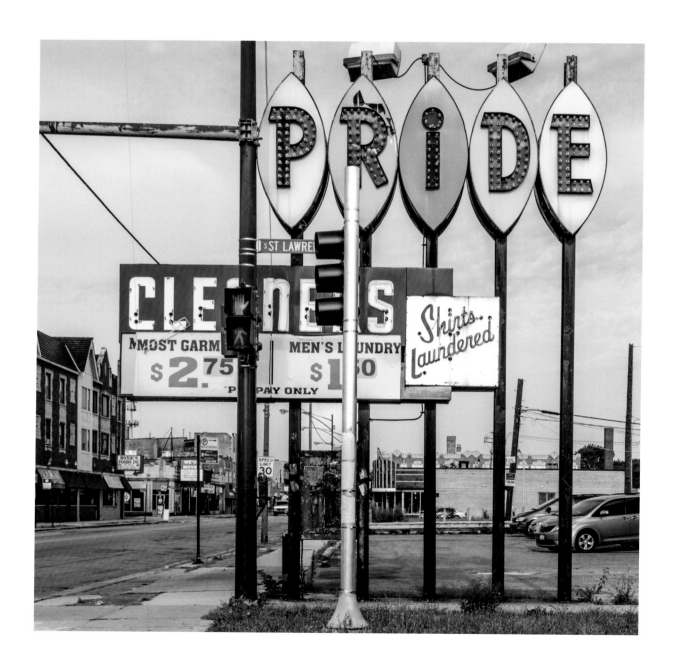

city—or back in time to pre-Columbian eras. On a hot day, there is no better place for relief than Sixty-Third Street Beach, a broad and sandy expanse backed by the lake. The beach's bathing pavilion is one of the best lakeside structures in the city—I might argue the best, actually. Built in 1919, the beach house is a generous, two-story concrete Classical Revival structure with hipped roofs and detailing that hint at the famed Prairie School. And for as long as I can remember, African drummers have assembled there during the warm evenings, playing to the crowd until the park closes at 11 P.M.

Hyde Park attorney and real estate developer Paul Cornell—the guy who developed Hyde Park—was among a group of developers and businessmen who pushed for more developed parks on the South Side after seeing how Central Park boosted real estate values in New York. The idea took root, and as years passed, smaller but significant regional parks developed around the South Side. Marquette Park is a three-hundred-acre jewel amid the working class bungalows and two-flats of the Southwest Side's Chicago Lawn neighborhood. Completed in 1917 and designed by the Olmsted Brothers company—run by Frederick Law Olmsted's sons—the park has expansive prairies, a lagoon, gardens, a nine-hole golf course, courts for tennis and basketball, and two baseball fields. There is also a sculpture of Dr. Martin Luther King Jr., who was hit in the head by a thrown brick when he led an open housing march through the park in 1966 when the area was predominantly white.

Midway Plaisance, between Fifty-Ninth and Sixtieth Streets
This broad, green, mile-long expanse between Cottage Grove and Stony Island Avenues connects Washington and Jackson Parks.

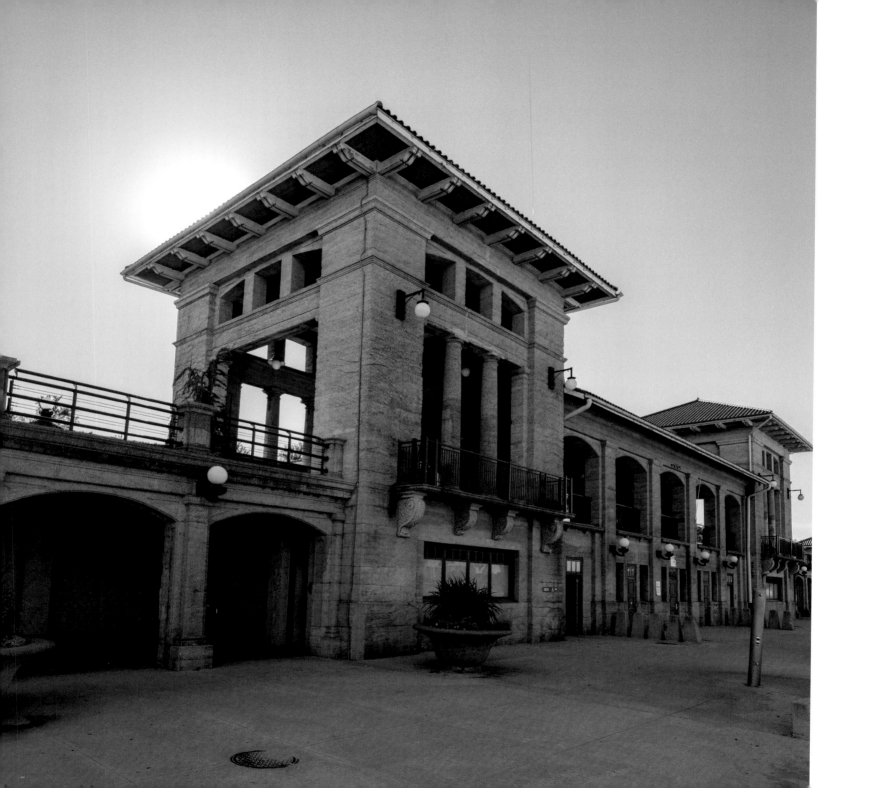

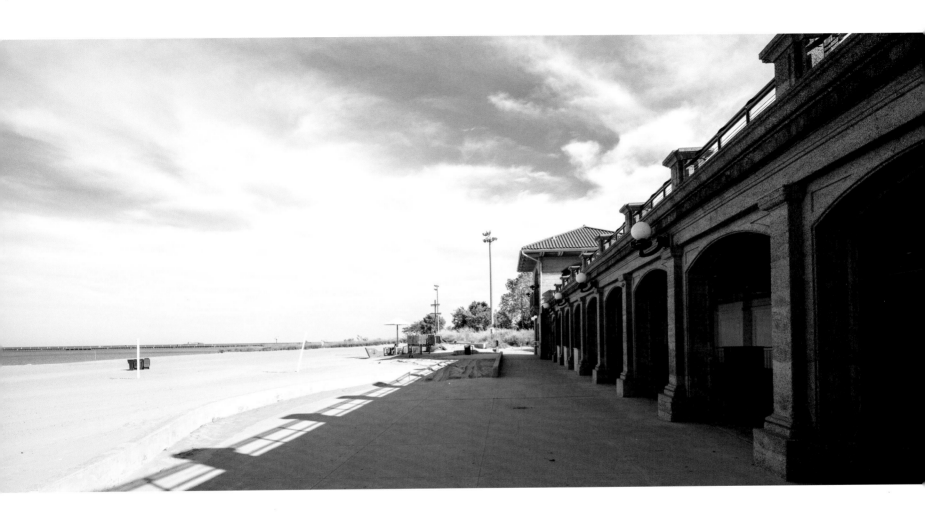

Jackson Park Beach House, Sixty-Third Street and the Lake

With balconies and beach-side galleries that overlook the lake, this 1919 Classical Revival beach house is among the most popular buildings on the South Side, especially on hot days.

Jackson Park Beach House, Sixty-Third Street and the Lake

Looking out at the lake from the beach house's ground-level loggia.

Quality green space, good architecture, and proper urban planning became hallmarks of many South Side neighborhoods, including Chicago Lawn, Hyde Park, South Shore, Englewood, and Woodlawn, because, "the private interest pushed it," says Chicago parks and architecture historian Julia Bacharach. "The profit potential. Paul Cornell is almost like an urban planner. And the reason why all the people went for it is because they believed creating livable, beautiful green neighborhoods with all of these fabulous amenities was worth the investment. I think it's also an understanding that commercial interests and public interest belong together."[1]

This linkage produced what is—hands down—one of the most surprising spots in the city, although comparatively little has been written or published about it: Auburn Lakes, a late nineteenth-century subdivision featuring homes surrounding an eight-acre, two-block-long lagoon and park.[2] Tree-lined Winneconna Parkway provides a picturesque loop around the Auburn Lake. Drive down West Seventy-Ninth Street, turn north on Eggleston Avenue, and this unique little area just leaps out.

"It just stops you," Naomi Davis, founder and president of Blacks in Green, a group that creates and supports green space and environmentally sustainable efforts on the South Side, said to me concerning Winneconna Parkway. "And you can probably feel your heart rate go down if you're able to indulge your curiosity and pull off the road to go in there and get out for a minute's walk."[3]

The venture was built in the 1880s as a speculative real estate development. The lake and parkland were privately owned, but were deeded to the city by 1913 and wound up under Chicago Park District authority in 1959.[4]

In its prime, the area also had its own medical facility, Auburn Park Hospital, built in 1917 overlooking the west end of the lagoon. The building was replaced by a larger,

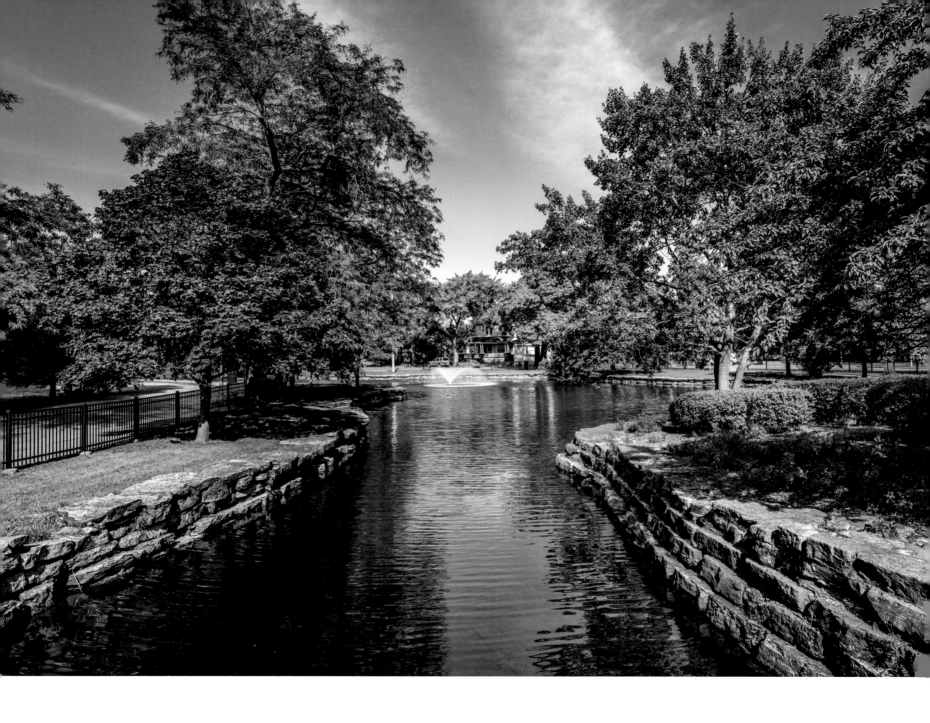

six-story Spanish Revival facility just before 1930. Hildy Johnson, the real-life *Chicago Herald American* newspaper reporter immortalized in Ben Hecht's 1928 play *The Front Page* died there in 1931 while being treated for a stomach hemorrhage.[5] The hospital, which became St. George's in 1939, was closed in the 1970s and demolished some years later.

After years of falling into disrepair, the lake and park were nicely restored in 2000 and once again became a gathering spot for the neighborhood. The linear, four-foot-deep lake has all the beauty of a re-created native prairie river with its rusticated limestone edges, waterfall, and rich landscaping and trees. Its stock of bullhead catfish draws anglers from all around.

The restored lake should have brought developers, capital, and rehabbers to Winneconna Parkway, and it's a shame that it hasn't. As a result, the collection of turn-of-the-last-century homes surrounding the lake—representing a range of styles from frame Victorians to brick bungalows, a 1920s apartment building, and an 1890s church—are kinda *just there*, occupied but in need of repair.

Davis said Chicago should be dotted with places like the Winneconna Parkway area. "Little oases in neighborhoods," she said. "It dignifies the human experience in a quiet but palpable way. It's how we ought to live."[6]

Live, yes, but what about death? Or more precisely, the afterlife? Turns out the South Side has made a design contribution here as well, in the form of beautiful Oak Woods Cemetery, located between Sixty-Seventh and Seventy-First Streets, Cottage Grove Avenue, and the current-day Metra Electric commuter rail line.

Auburn Lakes, Seventy-Eighth Street and Eggleston Avenue
This tranquil park and lagoon were built as part of an 1880s residential development.

Auburn Lakes, Seventy-Eighth Street and Eggleston Avenue

Another view of the lagoon and neighborhood, with a man fishing to the right of the photo along the shore.

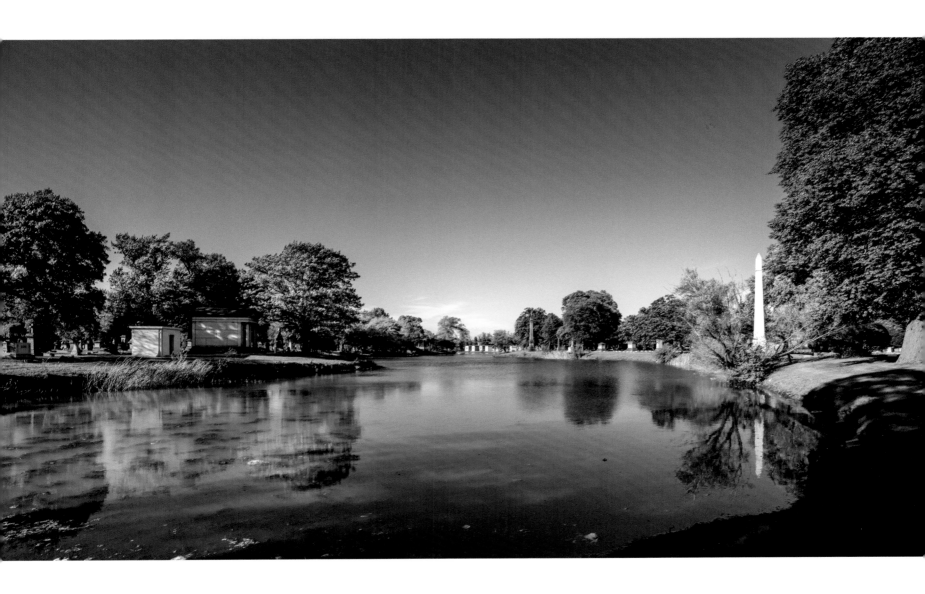

Oak Woods Cemetery, 1035 East Sixty-Seventh Street

With trees, lakes, and winding paths, this cemetery is a serene spot that was designed by landscape architect Adolph Strauch to be enjoyed by the living.

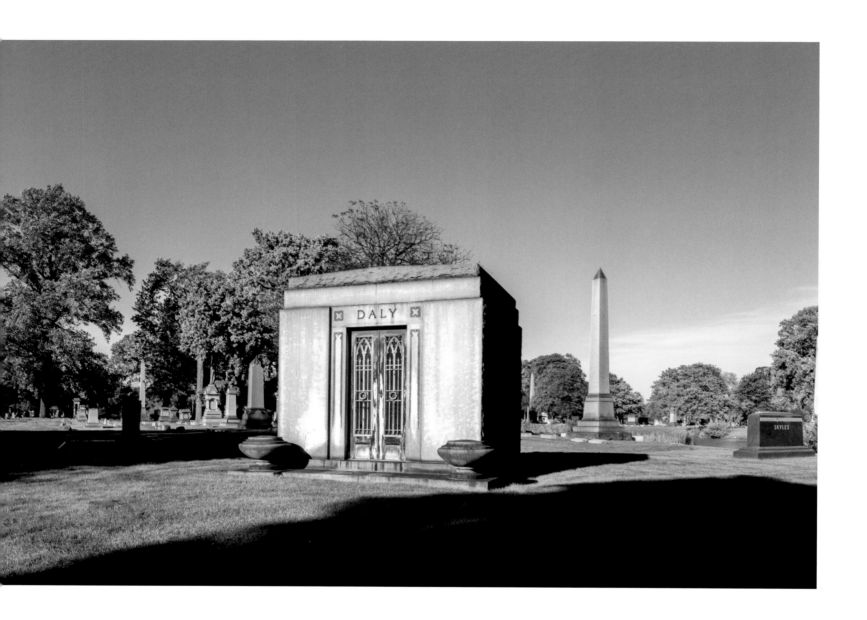

Michael Reese Hospital, which was once one of the top medical facilities and research hospitals in the country before it declined in the 1990s and closed in 2009. The Daley administration immediately acquired and began demolishing the entire campus—with the exception of one building—in hopes the cleared site near the lakefront and three miles from the heart of downtown would help Chicago's bid to snag the 2016 Summer Olympics.

Chicago lost to the Brazilian city of Rio de Janeiro. Also lost was the Reese campus, which had featured a mix of quality pre- and postwar buildings. The postwar addition was particularly noteworthy, as it featured eight buildings that were designed or co-designed by Bauhaus founder Walter Gropius, who also had a hand in a master plan that gave the hospital a humane and parklike modernist landscape designed by Hideo Sasaki. And an enviable set of one-of-a-kind postwar medical buildings was rashly sacrificed for this Olympic dream before they could be seriously considered for reuse.

The site's future remains cloudy. In 2018, the big parcel was one of several—along with $2.3 billion in city, state, and county incentives—offered by the city to Amazon in hopes of luring the retail giant's North American headquarters. Amazon opted for New York City (then pulled the plug on the project entirely in 2019 after a wave of community backlash over the $3 billion in public incentives set aside for the headquarters). At this writing, there are no city-approved and green-lit plans for the former Reese campus.

St. John of God Roman Catholic Church, 1234 West Fifty-Second Street

The Italian Revival church remained a well-kept architectural asset, even as it sat vacant for twenty years. It was demolished in 2011.

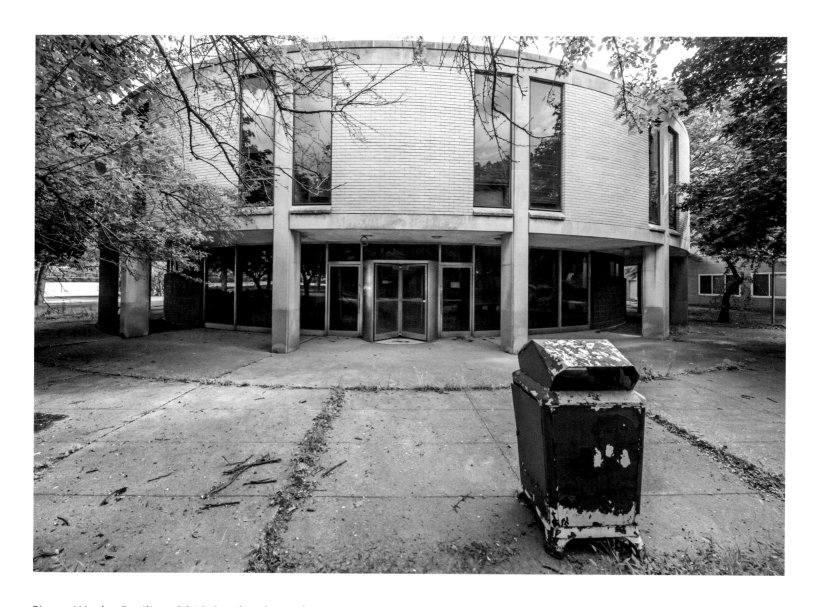

Simon Wexler Pavilion, 2960 South Lake Park Avenue (on the former Michael Reese Hospital Campus)

Designed by Ezra Gordon and Jack Levine and built in 1962, this modernist psychiatric research center was razed in 2011.

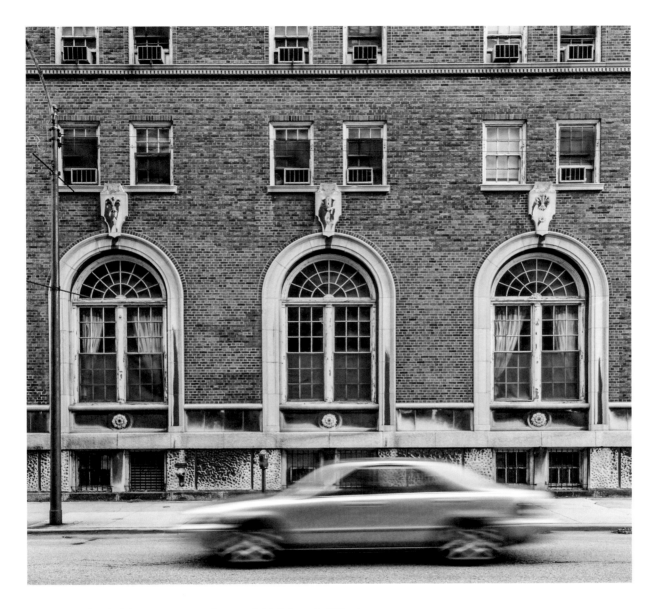

Hulda Rothschild Nurses Residence, 2816 South Ellis Avenue

A row of arched windows marked an expansive club-like sitting room for Michael Reese Hospital nurses who lived in this building. Built in 1892, the residence hall featured coffered ceilings and intricate woodwork. The building was demolished in 2010.

The Olympic bid cost almost $100 million in private funds, plus $91 million the city put itself on the hook for to buy the Reese property from Medline Industries. If only that $200 million could have been gathered and leveraged to preserve and reuse the Michael Reese campus rather than destroy it.

I've long feared McCormick Place's spectacular Lakeside Center convention hall will meet the same fate as Michael Reese. Former mayors Rahm Emanuel and Richard M. Daley made noises about demolishing the aging, flat-roofed hall at Twenty-Third Street and the lake, and returning the land to parkspace.

Granted, neither Lakeside Center, nor the burned-down predecessor it replaced, belong on Chicago's lakefront. But the building is one of the city's prime examples of steel-and-glass modernist architecture: a dark, brooding, swaggering *Chicago* of a building with more than three hundred thousand feet of exhibition space and a 4,200-seat theater set under a nineteen-acre cantilevered roof supported by only eight columns. Designed by Gene Summers, the architect who executed Mies's design for the New National Gallery in Berlin in 1968, and a young Helmut Jahn, Lakeside is the German building's scaled-up twin—and that's worth noting for reasons other than architectural trivia. With a new mayor in office in 2019, and as the McCormick Center convention complex expands westward and convention-related uses diminish for Lakeside, I'd like to see the city push for the building's reuse as a public arts, culture, and recreation destination that is worthy of its prime site.

Epilogue

I'm fifty-two years old as I write these words—a year older than my father was when he took me on that car ride all those many years ago.

I'm still a South Sider. And like my father, I travel about the area searching for new and undiscovered buildings and revisiting old haunts. Most times, I bring my camera along and note the good architecture that has come to my neighborhoods, especially in recent years. There are so many architecturally marvelous little buildings and neighborhoods that are hanging on or thriving—many more than I could include here. For instance, while hanging out with a buddy last year, I met Raymond Broady, a retired black architect. His face lit up when he found out I was writing this book.

"If you get a chance, go see a church I did a long time ago near 112th and Loomis," he said. "I think it's my best work." You could see the pride written on his face.

So I went to see Holy Name of Mary Church, at 11159 South Loomis Street, a nicely done midcentury building that sits at a forty-five-degree angle on its corner lot. Built on

a small budget for a black Catholic congregation that had been in the area since 1940, the church is a warm, modern, angular, and humanly scaled brick edifice that brings to mind the work of Eliel Saarinen or the late Chicago architect Harry Weese. It bothers me that I didn't have time to photograph it for this book.

I wish I had room for Pill Hill, a nicely maintained subdivision of well-tended California-style 1950s and early 1960s homes located on a prehistoric limestone ridge between Stony Island Avenue, Jeffrey Boulevard, Eighty-Ninth Street, and Ninety-Third Street. One summer evening in 2005, I drove my pre-teen daughters through Pill Hill. As we turned down Ninety-First Street, Dave Brubeck's 1959 jazz classic "Take Five" came on the car radio. The homes. The music. "We went back in time!" my oldest daughter joked.

The South Side neighborhoods of Roseland, Chatham, Gage Park, South Shore, Chinatown, McKinley Park, South Chicago, and Auburn Gresham each have enough good early twentieth-century architecture to singlehandedly fill a book. (So do the communities of Hyde Park, Kenwood, and Beverly, but the buildings in these neighborhoods have been well documented and protected over the years.)

I'm impressed with the Chicago Transit Authority's Ninety-Fifth Street station that opened in 2019. The facility is the last stop on the CTA's Red Line, and it finishes off the trip—or begins it—with a flourish.

CTA Red Line Terminal, 14 West Ninety-Fifth Street

This bright red transit station is a key link to downtown from the South Side. Replacing a smaller, fifty-year-old station, the facility features a pair of terminals connected by a 150-foot pedestrian bridge across Ninety-Fifth Street.

The $280 million station[1] is big and glassy, topped by a zoomy, eye-catching roof, canopies, and facade, all done up in a brilliant red. The interior features public art displays by artist Theaster Gates, including a working radio station and DJ booth that broadcasts music within the facility.[2]

The work of architecture and engineering firm EXP, the Ninety-Fifth Street station replaced a simple, functional late 1960s steel-and-glass terminus by SOM's Myron Goldsmith. Goldsmith originally designed the entire transit line—stations and all— from just south of downtown to Ninety-Fifth Street. The original terminal, as good as it was, seemed a bit puny perched above the considerable seven-lane width of the expressway and next to the girth of Ninety-Fifth Street, a major street that was made even wider to accommodate eleven bus lines that flow in and out of the station.

The new station doesn't hover above the Dan Ryan Expressway or cower by the roadside of Ninety-Fifth Street; it conquers them both by using good design to give more of the space to the pedestrian and transit rider, and less to the car. The South Side could use more victories like that.

The Forty-First Street bicycle and pedestrian bridge over Lake Shore Drive, completed in 2019, is another positive South Side project. The S-shaped bridge— held aloft by big twin inclined arches that flank the pathway—takes off from a park, then snakes eastward over the six-track Metra Electric railroad right-of-way and the expressway-like girth of Lake Shore Drive, landing beachside.

Pedestrian Bridge, Forty-First Street and Lake Park Avenue

At 1,470 feet, this serpentine bridge is slightly longer than Chicago's Willis Tower is tall— the length needed to carry bikers and pedestrians above active Metra Electric commuter rail lines and eight lanes of Lake Shore Drive.

Designed by Cordogan Clark & Associates and engineering firm AECOM, the sky-blue, $33 million bridge links the Bronzeville community to the lakefront. A twin to this bridge will be built at Forty-Third Street in 2020, and two connections join an eye-catching $26 million suspension bridge built in 2016 at Thirty-Fifth Street, designed by engineering firm EXP.

Together, the three bridges correct a lingering wrong on the South Side, where previously the only pedestrian access to the lake for residents of the Oakland, Douglas, and Grand Boulevard neighborhoods were the aged and non-ADA compliant bridges at Thirty-Fifth and Forty-Third Streets. The mile between those old bridges had no connection to the lake at all. Construction of the new bridges is an example of the city doing right by the South Side. Just keep it coming.

Possibly the South Side's biggest project in terms of notoriety and attention is the $350 million Obama Presidential Center taking shape on a twenty-acre site on the western edge of Jackson Park, near the Museum of Science and Industry. Designed by architects Tod Williams and Billie Tsien, the center's main design controversy is that it's being built on public land, and in a historic Olmsted-designed park, no less.[3]

I can live with the center being built in Jackson Park. Eleven major Chicago museums are located in public parks, a precedent that dates back to the construction of the Art Institute of Chicago in Grant Park in 1893. The problem is the center's design, especially its 235-foot tower that'll be clad in stone—granite, limestone, or marble. In renderings, the tower and the center's two other buildings look heavy and clumsy, like building pieces that fell to earth . . . sometime in 1975.

For a modern, progressive, and precedent-setting president, I expected something far more visually dynamic. Given its setting near the lake and abundant park space,

the architects should have designed a set of glassy, transparent, and organically shaped structures and plazas to look as if they came from nature. (And no tower looming over the park.) I wanted the designs to convey motion, color, and form with buildings that seem wedded to the landscape—at one with the prairie, if you will. There was enough design firepower at the table to come up with a far superior design.

The new mayor will have a huge role in deciding the future of all these South Side places and spaces. Mayor Lori Lightfoot, a black woman from the North Side, was elected to the big chair in April after Emanuel decided not to run for a third term.

Chicago has become two completely different cities, with a rich and well-appointed northern half and an increasingly tattered and disinvested South and West Sides. Look no further than the fate of two former historic Chicago steel mills for proof.

As I write these words, the city has given zoning approval to allow developer Sterling Bay to turn the old A. Finkl & Sons Steel plant on the western edge of the Lincoln Park community into Lincoln Yards: a new six-billion-dollar neighborhood of residential high-rises, retail space, parks—even three spots to catch a water taxi to downtown. To help fund this project in Chicago's richest neighborhood, the city will throw in nearly a billion dollars in public funds, raised through tax-increment financing.[4]

Sitting on the North Branch of the Chicago River, Lincoln Yards is the latest development in a bright new city-within-a-city—mostly middle-class and white—rapidly being built between Cermak Road and Fullerton Avenue, the lake and Ashland Avenue. Beginning in the 1990s but seemingly happening double-time since the real estate market rebounded from the 2008 crash, gleaming residential towers have been popping up so fast you can hardly remember the parking lot or two-story buildings that they replaced.

While a new community grows on the fifty-five-acre former Finkl Steel site, nearly six hundred acres on the south lakefront, once occupied by U.S. Steel's massive South Works plant, lie fallow, sprouting little more than weeds, tallgrass, and wildflowers.

What should have been the highest profile redevelopment project in the city—and perhaps a national model of how to redevelop brownfield sites—is essentially dead in the water. Developers from Ireland and a modular home builder from Spain planned to build a new neighborhood of twenty thousand new homes on the cleared 589-acre site where U.S. South Works once stood. But the home builder, Barcelona Systems, abandoned the project in April 2018 after possible soil contamination issues came to light. A month later, the developer walked away too.[5]

Finkl closed in 2014 and its land was snapped up Sterling Bay for $100 million two years later. South Works has been idle for a quarter century. Before the Barcelona Systems deal, a previous residential redevelopment for the site also fell through, after the city spent millions creating a boulevard through the site. It's a fine road—to virtually nowhere. One can't help but think: nearly six hundred clear acres right on the Lake Michigan shore, about a twenty-five-minute drive from downtown in clear traffic, and no one can do a thing with it?

"If those acres were on the North Side, that's where Amazon would be looking," Pacyga said. "But it's *out there*. Even to some South Siders. There is this image that the South Side, the Far South Side are so far away."[6]

Perhaps the city and USX, the steel manufacturer who still owns the site, should follow Paul Cornell's lead and turn at least half the area into a public park. Given that parks are one of the things Chicago does exceptionally well—often adding major

cultural attractions such as museums among the trees, flowers, and grass—the park could be a proper and substantial addition to the lakefront park system, and a shot in the arm to the aged South Chicago community that has suffered so much since the mills closed. And maybe it might get some houses built.

But it'll still take leadership and vision from City Hall to get there. As mayor, Lightfoot must work—and hard—to bring development to South Works and the greater South Side, while pushing back conceptions that the area is too far, too poor, too *out there*.

And that begins with an understanding that the South Side, at 142 square miles, is the size of Philadelphia. That much area requires urban planning and redevelopment at an inventive and sophisticated city scale. Both Emanuel and Daley were good at scoring base hits for the South Side. Lightfoot has to swing for the fences and dismiss small-scale urban planning and catch-as-catch-can deals done without a larger plan for the area.

The Obama Presidential Center, likely to be built on Lightfoot's watch, could be one of those home runs. But at this writing, the Obama apparatus only argues for what it needs to get the center built—things like park space, wider roads, closed-off streets, and room for parking. It has yet to really roll up its sleeves or use its clout to push for—or help fund—tangible amenities that would help both the center and the surrounding area.[7]

For instance, the city and the Obamas should be fighting to rebuild the elevated CTA Green Line tracks and stations that once ran down East Sixty-Third Street between Cottage Grove and Stony Island Avenues. In one of city's worst planning blunders, the mile-long leg of track was demolished in 1997. But the rebuilt mile section would

bring patrons from downtown to within a short walk of the presidential center. And it would put back an important transit link for South Side residents while improving redevelopment efforts along Sixty-Third Street.

Object lesson: The Green Line station at Sixty-Third Street and Cottage Grove Avenue was spared demolition, and since 2016, the intersection has come alive with new transit-oriented retail and mixed-use development. This is the kind of action the South Side needs.

The absence of a true plan to embrace and help the South Side has bred a certain cynicism on that side of town. I'd wager it's occurring on the West Side also. There is an open and ongoing discussion among black people that we are no longer welcome in Chicago and that the city's government, civic leaders, and policymakers are purposely chasing black people out of the city by not fully reinvesting in the South and West Sides.

And it's playing out to some extent with a historic depopulation that's happening now in the South Side's black neighborhoods. More than 240,000 black people— mostly South Siders—have left Chicago since 2000 and are taking up residence in jobs-rich Northwest Indiana and Southern cities.

The Grand Boulevard neighborhood had a population of 53,000 in 1980 when my father and I took our drive. Fewer than 22,000 live there now.[8] On the far edge of the South Side, the Roseland community's population has fallen to about 22,000 from 64,000 in 1980.[9]

The Washington Park neighborhood directly west of the University of Chicago was a largely working-class black community of nearly 60,000 before World War II. Today about 12,000 people live there.[10] Along with the population plunge, demolitions have left this one neighborhood with a mind-boggling five hundred parcels of vacant land.[11]

The population's free fall puts the South Side's architecture at additional risk, particularly churches and schools that were sized and built during the area's boom years. One example is Harper High School at Sixty-Fifth and Wood Streets in the West Englewood neighborhood; it is being phased out because there are hardly enough students to fill its classrooms.

Harper had 585 students in 2000, but only 185 pupils attended the school in 2017.[12] The facility was built in 1911 to hold well over 800. The neighborhood itself lost more than 10,000 residents in the same time period.

Harper was designed by Dwight Perkins, who merged bits of Prairie, art deco, and Mayan influences into a beautiful structure: an architectural bright light in what is now a severely disinvested neighborhood. And what will happen to this building, once it's closed in a handful of years? Not much, if past is prologue. When the Emanuel administration closed forty-seven schools across the city in 2013 on the grounds that they were underenrolled and underperforming, the city and school officials didn't have a reuse plan for the empty buildings. Today, most are vacant.[13] There is a good chance that Harper High School, as beautiful as it is, will wind up the same way. And unless there is change—and now—the school's fate could also serve as a metaphor for the South Side itself.

As mayor, Lightfoot has to work to reverse this population exodus—or at least stem the flow. That means inventive and sophisticated redevelopment efforts planned at a city scale, and aimed at rebuilding the South Side and retaining and growing its population. And she certainly must correct and keep clear of the type of corrosive and cavalier policies of her predecessor that led to the mass school closings—with no public discussion beforehand, or clear public benefit afterward.

Granting city landmark status to more South Side buildings also would be a key step, along with creating more landmark districts on the South Side. Such a move would keep away bulldozers and preserve the South Side's trove of good architecture. And for homeowners there are local and state tax incentives and permit-fee waivers designed to help owners restore historic properties. All of these could ease the burden of home ownership and help rebuild communities.

Black and brown people started coming to the South Side more than a century ago in hopes of finding the first-class citizenship and opportunities that were denied them elsewhere. The decades that followed brought astonishing achievements for many people of color on the South Side. The buildings tell part of that story.

But the buildings and neighborhoods tell another story also: that for black people those hundred-plus years were also filled with restrictive housing covenants; racist city policies; the historically brutal ways black neighborhoods have been policed; the economic, social, and cultural disinvestment of the South and West Sides—and now the astonishing wealth and privilege being built and put on display in the form of the new and predominantly white high-rise neighborhoods around the outskirts of downtown.

If the city's political, cultural, and civic leadership care at all about Chicago, now is the time to stand up for the South Side and the West Side, bringing forth bold, visionary, *audacious* plans needed to revive and support these areas, their buildings, and the people who live there.

It's time to write a new chapter for Chicago's South (and West) Side. Let it begin now.

NOTES

INTRODUCTION

1. James R. Grossman, Ann Durkin Keating, Janice L. Reiff, eds., *Encyclopedia of Chicago* (Chicago: University of Chicago Press, 2004), 771.

2. Lee Bey, "A Landmark Church Forsaken by Time," *Chicago Sun-Times*, June 15, 1997, 19.

3. Andre Perry and Nathan Rothwell, "The Devaluation of Assets in Black Neighborhoods," Brookings Institution, November 2018, 3.

4. Huping Ling, *Chinese Chicago: Race, Transnational Migration, and Community since 1870* (Stanford, Calif.: Stanford University Press, 2012), 53.

5. David Masciotra, "Senators Durbin's and Kirk's 'Elitist, White-Boy' Plan to Fight Gangs Is Right," *The Atlantic*, June 7, 2013, https://www.theatlantic.com/politics/archive/2013/06/senators-durbins-and-kirks-elitist-white-boy-plan-to-fight-gangs-is-right/276656/.

CHAPTER 1

1. Isabel Wilkerson, *The Warmth of Other Suns: The Epic Story of America's Great Migration* (New York: Random House, 2010), 556.

2. Bryan Stevenson, interview with the author, Equal Justice Initiative headquarters, Montgomery, Alabama, May 10, 2018.

3. Natalie Y. Moore, *The South Side: A Portrait of Chicago and American Segregation* (New York: St. Martin's Press, 2016), 40.

4. Gerald D. Jaynes, *Encyclopedia of African American Society, Volume 1* (Thousand Oaks, Calif.: Sage Publications, 2005), 539.

5. Richard Brent Turner, *Islam in the African-American Experience* (Bloomington: Indiana University Press, 2003), 71–72.

6. Grossman, Keating, and Reiff, eds., *Encyclopedia of Chicago*, 945.

7. Geneva Allen, telephone interview with the author, Chicago, May 24, 2018.

8. "Complete Plans for $1,000,000 Pythian Temple," *Chicago Daily Tribune*, July 6, 1924.

9. Dreck Spurlock Wilson, *African American Architects: A Biographical Dictionary, 1865–1945* (New York: Routledge, 2004).

10. Christopher R. Reed, *The Rise of Chicago's Black Metropolis, 1920–1929* (Champaign: University of Illinois Press, 2011), 54.

11. Lee Bey, "Black Designer All But Forgotten," *Chicago Sun-Times*, February 9, 1998, 13.

12. Ibid.

13. "Water Shut Off; 6 Couples Stranded," *Chicago Tribune*, September 1, 1978.

14. Lee Bey, "Black Designer All But Forgotten," *Chicago Sun-Times*, February 9, 1998, 13.

15. Lee Bey, "City Gives Bronzeville New Hope for Landmark Status," *Chicago Sun-Times*, April 29, 1996, 4.

16. Lee Bey, "City Embraces 9 Landmarks in Bronzeville," *Chicago Sun-Times*, August 7, 1997, 8.

17. Paula Robinson, telephone interview with the author, May 18, 2018.

18. Commission on Chicago Landmarks, Black Metropolis-Bronzeville District. City of Chicago preliminary staff summary of information report, August 28, 1997 (Chicago: Commission on Chicago Landmarks), 16.

19. Mary Beth Klatt, "The Big Picture," *Chicago Reader*, February 21, 2002, https://www.chicagoreader.com/chicago/the-big-picture/Content?oid=907835.

20. Heather Vogell, "YMCA'S Rebirth Spurs New Hope, Old Memories," *Chicago Tribune*, April 1, 2001.

21. Klatt, "The Big Picture."

22. Commission on Chicago Landmarks, Black Metropolis-Bronzeville District. City of Chicago

preliminary staff summary of information report, August 28, 1997 (Chicago: Commission on Chicago Landmarks), 16.

23. Lee Bey, "Rebuilding the Overton Legacy," *Chicago Sun-Times*, April 28, 1996, 8.

24. Lee Bey, "A Renovation for the Books: Bronzeville Bee Building Now Library," *Chicago Sun-Times*, April 28, 1996, 8.

25. "Eighth Regiment Armory," City of Chicago, accessed May 12, 2018, https://webapps .cityofchicago.org/landmarksweb/web/landmarkdetails.htm?lanId=1294.

26. Joseph Gustaitis, *Chicago Transformed: World War I and the Windy City* (Carbondale: Southern Illinois University Press, 2016), 78.

27. Ray Quintanilla, "2 More City Schools to Go Military; Carver, Calumet Join Bronzeville," *Chicago Tribune*, November 12, 1999.

28. Alice Sinkevich and Laurie McGovern Petersen, eds., *AIA Guide to Chicago*, 3rd ed. (Champaign: University of Illinois Press, 2014), 391.

29. Dennis Rodkin, "What's That Building? The Sunset Cafe Mural," *WBEZ* (blog), May 24, 2018, https://www.wbez.org/shows/morning-shift/whats-that-building-the-sunset-cafe-mural /ad11a2c2-b786–4477-be32–7f93caf5439f.

30. "The Renaissance Collaborative History," The Renaissance Collaborative, accessed June 6, 2018, https://www.trcwabash.org/history.html.

31. Oscar Corrall, "A Church on the Brink, Judge Orders Decaying 1886 Building Demolished," *Chicago Tribune*, August 13, 1998.

CHAPTER 2

1. Grossman, Keating, and Reiff, eds., *Encyclopedia of Chicago*, 22.

2. John L. Riley, *The Once and Future Great Lakes Country: An Ecological History* (Montreal: McGill-Queens University Press), 287.

3. F. C. Francis, "The Story of Englewood," *Pere Marquette Magazine*, vol. 11 (May 1919), 39.

4. "Iron and Steel," *Encyclopedia of Chicago*, accessed May 17, 2017, http://www.encyclopedia .chicagohistory.org/pages/653.html.

5. Dominic A. Pacyga, telephone interview with the author, March 27, 2018.

6. Commission on Chicago Landmarks, Neighborhood Bank Buildings, City of Chicago preliminary staff summary of information report, December 6, 2007, 14.

7. D. Bradford Hunt, telephone interview with the author, April 10, 2018.

8. *Chicago Examiner*, July 25, 1909, F-6.

9. Robin F. Bachin, *Building the South Side: Urban Space and Civic Culture in Chicago, 1890–1919* (Chicago: University of Chicago Press, 2004), 36.

10. "Cobb Lecture Hall," Architecture at the University of Chicago, accessed June 2, 2018, https://architecture.uchicago.edu/locations/cobb_lecture_hall/.

11. Sinkevich and Petersen, *AIA Guide to Chicago*, 49.

12. Ibid., 385.

13. Lee Bey, "The Architecture of Chicago's First Office Park," *WBEZ* (blog), accessed April 5, 2018, https://www.google.com/amp/s/www.wbez.org/shows/wbez-blogs/the-architecture-of-chicagos-first-office-park/08bf4c9b-5a21–493b-9ea4–8ee40b02facd/amp.

14. *The Central Manufacturing District: Chicago Junction Railway Service* (Chicago: Central Manufacturing District, 1915).

15. Sinkevich and Petersen, *AIA Guide to Chicago*, 407.

16. Paul Meinke, "CFD Determines Warehouse Fire Was Set," *ABC7 Chicago News*, January 25, 2013, http://abc7chicago.com/archive/8968477/.

17. Sinkevich and Petersen, *AIA Guide to Chicago*, 407–8.

18. Dian O. Belanger, "The Corliss at Pullman," *Technology and Culture* 25, no. 1 (1984): 83–90.

19. "Planning the Town of Pullman," Pullman State Historic Site, accessed March 20, 2018, http://www.pullman-museum.org/theTown/planning.html.

20. "Salts Mill," accessed March 12, 2018, http://saltsmill.org.uk/mobile/.

21. Sinkevich and Petersen, *AIA Guide to Chicago*, 482.

22. "Pullman to Receive Monument Designation," *Chicago Tribune*, February 10, 2015.

23. Tony Briscoe, "Pullman National Monument Plans Pick Up Steam," *Chicago Tribune*, January 20, 2016.

24. "Salts Mill," accessed March 12, 2018, http://saltsmill.org.uk/mobile/.

25. Tony Briscoe, "Progress on Pullman Monument Out of Steam," *Chicago Tribune*, February 19, 2018.

CHAPTER 4

1. "Huge Vocational School Finished," *Chicago Daily Tribune*, August 4, 1940.

2. Commission on Chicago Historical and Architectural Landmarks, "City of Chicago Landmark Designation Report, April 7, 1978" (Chicago: Commission on Chicago Historical and Architectural Landmarks, 1978).

3. Austin C. Wehrwein, "Chicago U. Hails New Law Center," *New York Times*, October 4, 1959.

4. Ibid.

5. "UNO Soccer Academy," *World-Architects: Profiles of Selected Architects*, February 20, 2012, https://www.world-architects.com/it/architecture-news/reviews/uno-soccer-academy.

6. "News of the Architects," *Chicago Daily Tribune*, May 25, 1947.

7. "Cornell Church, Burned Out, to Rise Again Soon." *Chicago Daily Tribune*, February 19, 1953.

8. Dominic A. Pacyga, telephone interview with the author, March 27, 2018.

9. Sinkevich and Petersen, *AIA Guide to Chicago*, 415.

10. "First Church of Deliverance," City of Chicago preliminary staff summary of information report, July 6, 1994 (Chicago: Commission on Chicago Landmarks), 6.

11. Dominic A. Pacyga, *Chicago: A Biography* (Chicago: University of Chicago Press, 2009), 138.

12. *Visit Toulouse*, French Tourism Office, June 13, 2011, http://us.france.fr/en/discover/visit-toulouse-0.

13. "Chicago Public Library—Chinatown Branch," SOM, accessed June 2, 2018, https://www.som.com/projects/chicago_public_library_chinatown_branch.

CHAPTER 5

1. Joanna Trotter, telephone interview with the author, March 4, 2019.

2. Maureen O'Donnell, "Pioneering Architect Roger Margerum Dead at 85," *Chicago Sun-Times*, August 30, 2016, https://chicago.suntimes.com/news/pioneering-architect-roger-margerum-dead-at-85/.

3. Blair Kamin, "Restoration of Church, Apartment Complex Reveal Value of Neighborhood Architectural Gems," Tribune Interactive, LLC, August 5, 2017.

4. Lee Bey, "South Side Streets Hold City's Treasures," *Chicago Sun-Times*, May 7, 2001, 6.

5. "Rhodes Theater," *Cinema Treasures*, accessed May 15, 2018, http://cinematreasures.org/theaters/4719.

6. McKinley Williams Bey, email to author, May 12, 2018.

7. Peter Pope, Facebook message to author, March 27, 2018.

CHAPTER 6

1. Julia Bacharach, telephone interview with the author, April 27, 2018.

2. "Auburn Park," Chicago Park District, accessed April 6, 2018, https://www.chicagoparkdistrict.com/parks-facilities/auburn-park#History.

3. Naomi Davis, telephone interview with the author, May 18, 2018.

4. "Auburn Park" Chicago Park District, accessed April 6, 2018, https://www.chicagoparkdistrict.com/parks-facilities/auburn-park#History.

5. "Hilding Johnson Dies; Hero of 'Front Page,'" *New York Times*, March 24, 1931.

6. Naomi Davis, telephone interview with the author, May 18, 2018.

CHAPTER 7

1. "Lost Landmark: St. Basil's Catholic Church," July 9, 2012, https://www.wbez.org/shows/wbez-blogs/lost-landmark-st-basils-catholic-church/7d2d399d-99a1433a-aa39-a16a5309b8a2.

2. Lee Bey, "Shuttered South Side Church Begins Trek to a New Life in Lake County Today," *WBEZ Beyond the Boat Tour* (blog), August 31, 2010, https://www.wbez.org/shows/wbez-blogs/shuttered-south-side-church-begins-trek-to-a-new-life-in-lake-county-today/758366c8–9b69–43c1-bc7a-1ec3b63a1df4.

EPILOGUE

1. Mary Wisniewski and William Lee, "Red Line Extension Finally a Go, but No Green for Funds," *Chicago Tribune*, January 27, 2018.

2. William Lee, "Art at CTA Station Nods to the Black Experience," *Chicago Tribune*, July 13, 2017.

3. Deanna Isaacs, "A Lawsuit to Prevent the Obama Presidential Center's 'Illegal Land Grab' in Jackson Park Is Moving Forward," *Chicago Reader*, August 17, 2018. https://www.chicagoreader.com/chicago/obama-presidential-center-jackson-park-lawsuit-protect-our-parks/Content?oid=55871246.

4. Jay Kozlarz, "Lincoln Yards Approved by Chicago City Council, Only TIF Votes Remain," *Curbed Chicago*, March 14, 2019, https://chicago.curbed.com/2019/3/14/18263765/lincoln-yards-approved-city-council-emanuel-tif.

5. Mitch Dudek, "Developer for South Works Site Ends Contract," *Chicago Sun-Times*, May 24, 2018, https://chicago.suntimes.com/business/developer-for-south-works-site-ends-contract/.

6. Dominic A. Pacyga, telephone interview with the author, March 27, 2018.

7. Angela Caputo and Dahleen Glanton, "Could Obama Library Turn Tide on Decades of Neglect?" *Chicago Tribune*, June 20, 2016.

8. Rob Paral and Associates, "Chicago Community Areas Historical Data," accessed June 10, 2018, http://www.robparal.com/downloads/ACS0509/HistoricalData/Chicago%20Community%20Areas%20Historical%20Data.htm.

9. Ibid.

10. "Community Data Snapshot—Washington Park" (PDF), cmap.illinois.gov, MetroPulse, accessed March 30, 2018.

11. Rob Paral and Associates, "Chicago Community Areas Historical Data," www.robparal.com.

12. "Harper High School," Illinois School Report Card, Illinois State Board of Education, accessed June 8, 2018, https://www.illinoisreportcard.com/School.aspx?source=studentcharacteristics&source2=enrollment&Schoolid=150162990250017.

13. Kaylin Belsha and Bill Healy, "Empty Schools, Empty Promises," *Chicago Reporter*, February 24, 2018, http://www.chicagoreporter.com/series/empty-schools-empty-promises/.

INDEX

Second to None: Chicago Stories celebrates the authenticity of a city brimming with rich narratives and untold histories. Spotlighting original, unique, and rarely explored stories, Second to None unveils a new and significant layer to Chicago's big-shouldered literary landscape.

Harvey Young, series editor